SOUTHAMPTON SPEEDWAY

BANISTER COURT STADIUM

GREYHOUND RACING
UNDER N.G.R.C. RULES

MONDAYS
WEDNESDAYS
SATURDAYS
At 7.30

NOW FIRMLY ESTABLISHED

Southampton's
Sports Centre
and
Arena

FRIDAY NEXT
PONY PACING
RACES
AT NIGHT UNDER ELECTRIC LIGHT

EVERY FRIDAY
7.30 - 1/3

DIRT TRACK SPEEDWAYS LTD., LONDON. Will Present

BANISTER COURT

SPEEDWAY

Grand Opening Meeting
ON THE

DIRT MOTOR-CYCLE RACING TRACK

OCT. 6 SATURDAY OCT. 6

EIGHTEEN THRILLING EVENTS !!!

SPROUTS ELDER
U.S.A.

Including
A CLASH
between

IVOR CREED
England

DATE:	Roger FROYLEY · Buzz HIBBERD Billy GALLOWAY · Jack ADAMS Dudley FROY and other English and Australian CRACKS	TIME:
OCT. 6		**3 o'clock**

BANISTER COURT STADIUM

Intending Local Competitors make immediate application to Alec Bennett, Broadway, Portswood

The advertisement in the local press for the first-ever dirt-track meeting at Banister Court Stadium on Saturday 6 October 1928. Notice that there are some inaccuracies in the spelling of the riders' names.

SOUTHAMPTON SPEEDWAY

PAUL EUSTACE

The
History
Press

Cover photo credit

Jim Squibb, in action against Belle Vue in 1958, has ridden in all three divisions of the National League for Southampton. He is the all-time highest points scorer and has made the most league appearances for the Saints. (A.C. *Weedon*)

First published in 2002 by Tempus Publishing
Reprinted 2005

Reprinted in 2010 by
The History Press
The Mill, Brimscombe Port,
Stroud, Gloucestershire, GL5 2QG
www.thehistorypress.co.uk

British Library Cataloguing in Publication Data.
A catalogue record for this book is available from the British Library.

ISBN 978 0 7524 2433 0

Typesetting and origination by
Tempus Publishing.
Printed and bound in Great Britain by
Marston Book Services Limited, Didcot

Contents

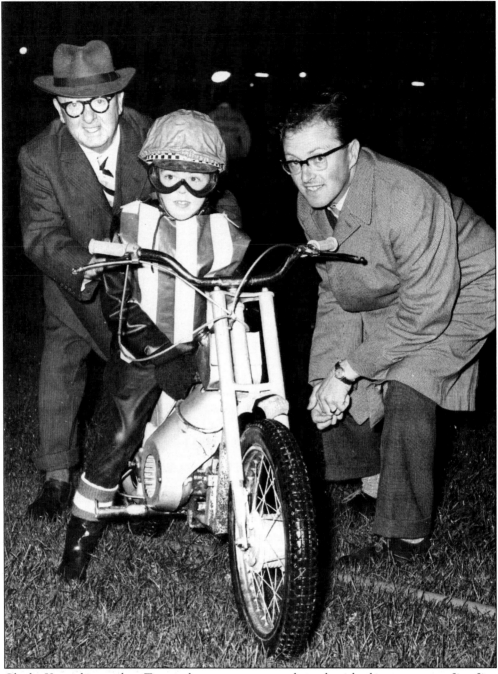

Charles Knott, his grandson Tony – the team mascot – and, on the right, his youngest son Jim. Jim, Tony's father, was the Saints' mascot in the mid-1930s. They are pictured together on 3 October 1963, the last time speedway was held at Banister Court Stadium. (Southern Newspapers Limited)

Foreword

When Paul Eustace first approached me in his search for photographic memories of Southampton Speedway, it quickly became clear that here was a man not only with a great interest in speedway, but also someone who paid particular attention to detail and accuracy. Over many hours of conversation, a story has emerged that might otherwise have remained hidden.

Having been born around the time speedway started in Southampton, the early stars such as 'Sprouts' Elder, Jimmy Hayes and Clarrie Eldridge are just names whose exploits were related to me by my father. Later riders, like Jack Parker, Ernie Rickman and Vic Collins, became easily recognisable. In the mid 1930s, when I was the team mascot, the leg-trailers like Saints' captain Frank Goulden, Billy Dallison and Bert Jones were still able to hold their own against the foot forward stylists. The tracks consisted of deep cinders and I recall having great difficulty riding my small bike across the wheel marks. When the foot forward style came into more general use, tracks had to become much slicker and riders such as Cordy Milne, Sid Griffiths and Jim Boyd became more prominent. I believe that the partnership of Milne and Griffiths was one of the most successful pairings that the Saints have had.

My father, the late Charles Knott, the 'Guv'nor', who did so much to establish speedway in this country, particularly at Southampton, was an admirer of rider courage. He was also insistent on spectacle and presentation. The public came first and foremost in his mind and they were to have the best. The stadium became one of the most respected in the land, in all aspects. Many of the staff gave long and loyal service to the stadium and the 'Guv'nor', which contributed to the success of the organisation.

When speedway resumed after the war, the public, starved of entertainment for six years, flocked back in their thousands to the thrills of the sport. Some of the old riders returned, and many more came from grass-track racing. Supporters will remember George Bason, Jim Squibb, Bert Croucher, Alf Bottoms, Cecil Bailey, Peter Robinson and the Oakley brothers, who all rode for Southampton in the early post-war days. At Banister Court, a track surface of sand was used to protect the greyhound track, but it was later discontinued in favour of shale. The early excitement the sport provided was difficult to maintain as people returned to the normality of peacetime living.

In 1952, the 'Guv'nor' became more intensely involved. He started from scratch, and arranged practice days open to all with ambition and enthusiasm. A new team was formed and favourites emerged like Brian McKeown, Mike Tams, Maury Mattingly, Dudley Smith, Ernie Rawlins, Brian Hanham and, later, Alby Golden. The crowds returned and success was assured when riders of the calibre of Dick Bradley, Brian Crutcher, Bjorn Knutsson and Barry Briggs were signed. This success culminated in the National League title being won in 1962.

My father had achieved his lifetime ambition and, with my brothers, Charles and Jack, who had done so much to support him behind the scenes, now successfully promoting Poole Speedway, the stadium was sold to the Rank Organisation and racing ceased at Banister Court.

Over the years, efforts have been made to find other venues, but to no avail. In 1998, a Seventieth Anniversary reunion was held near the old stadium site, now a housing development. Former riders attended, along with many supporters, leading one to believe that speedway could once again prosper in Southampton. If it does happen, it will perhaps be different from how we knew it in the past. Charles Knott, the driving force behind Southampton Speedway, was the right man in the right place at the right time.

I believe this book to be an important addition to any library, and it will be thoroughly enjoyed by all with an interest in speedway. My congratulations go to the author for compiling such a comprehensive story of Southampton Speedway.

Jim Knott
January 2002

Acknowledgements

This book is principally a photographic record of Southampton Speedway, and the majority of the photographs used are from the personal collection of Jim Knott, to whom I am deeply indebted. Some photographs were acquired without knowing their origin, but every effort has been made to credit the sources where possible.

My thanks and acknowledgement go to Wright Wood, C.F. Wallace, E.G. Patience of Regent Studios, A.C. Weedon, Leonard Birch, Cecil Bailey, Gordon Elsworth, the *Hampshire Advertiser* and Southern Newspapers Limited.

My gratitude is also expressed to the writers and editors of newspapers, books, journals and articles that have been consulted, such as the *Southern Daily Echo*, the *Southern Evening Echo*, *Stenner's Speedway Annuals*, *People Speedway Guides*, *Five Star Annuals*, *Speedway Panorama*, *Ride It – The Complete Book of Speedway*, *British Speedway Leagues 1946-1964*, *Speedway News*, *Speedway World*, *Speedway Star*, *Vintage Speedway Magazine*, and Southampton Speedway programmes and brochures.

Finally, I wish to dedicate this book to my lovely wife, Jennie, for her patience with me over the years while I have been 'cutting out and sticking in'.

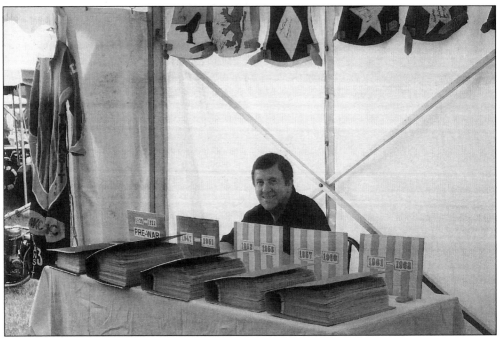

The author and his History of the Saints albums at the Beaulieu Motor Cycle World in June 2001.

Introduction

My earliest recollection of Southampton Speedway is of George Bason winning the 'Southampton Trophy' competition, at the first meeting at Banister Court after the Second World War, on Tuesday 29 April 1947.

For weeks afterwards, when I was riding my bike, in my mind I was George Bason. I met George, then in his eighties, at the Saints' Seventieth Anniversary at the Avenue Hall, Southampton, on Saturday 17 October 1998, and was able to tell him what a hero of mine he had been. He modestly commented that he still had the machine that he had used on that day all those years before.

The late 1940s were the boom years of speedway, but my best memories of Banister Court are when promoter Charlie Knott reintroduced the sport in 1952 and the stadium became the place to be on a Tuesday night. Two thousand colourful fairy lights were strung around the perimeter of the track and a well-manicured centre green with attractive flower beds and a spectacular crown of lights on an illuminated tower, built specially for the Coronation Year, made for a very smart stadium.

It is not easy to describe the atmosphere that was created, but I know it was something I shared with thousands of others – in recent years, when I have met many of the supporters, they have told me that they felt the same magic that I did.

I cannot remember exactly what made me begin, but over twenty years ago I started to collect Southampton Speedway memorabilia. Initially, the material was housed in one album, but the collection has grown into a five-album history of the Saints. Finding new photographs and information has become a major hobby and over seventeen hundred photographs and nearly two thousand pages have been gathered. This is thanks to the kindness and generosity of speedway friends like Jim Knott, Jane Collins, Andy Scorey, Graham Seymour, Graham Haynes, Andy and Tony Day, John Sharp, Ivan Martin, Vic Butcher, Maurice Jones, Cecil Bailey, Terry Lane-Smith and the late Bill and Kath Giles.

Andy Scorey, the main organiser of the reunion, asked me to display the albums, and they are also seen every year at the Beaulieu Motor Cycle World. It has often been suggested that a book should be written based on my collection and it is very pleasing that there has been such a favourable reaction to what is, in effect, purely a hobby based on my interest in Southampton speedway.

Although Chris Bayley's excellent book on the stadium, published in the early 1990s, included a section on speedway, to my knowledge there has not been a book published specifically on Southampton Speedway. My thanks are due to James Howarth of Tempus Publishing who, in a number of conversations, made me realise that there should be something on record to give recognition to what was an important feature of Southampton life that brought pleasure to thousands of people. I would also like to thank Jim Knott for agreeing to write the foreword. The Knotts are synonymous with Southampton Speedway and it is entirely appropriate that a member of the family should be involved in this publication.

· The aim of the book is not to fill the pages with countless statistics, but to try, mainly through photographs, to create a chronological awareness of a very special speedway club.

Paul Eustace
February 2002

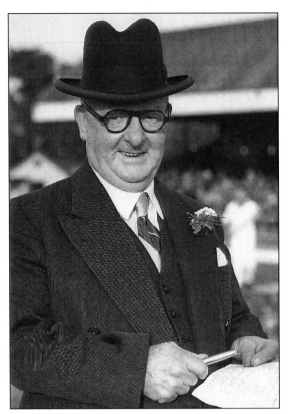

Charles Knott, or the 'Guv'nor' as he was known, was the main man behind the success of Southampton Speedway at Banister Court Stadium from 1928 to 1963.

The site which was purchased by the newly-formed Southampton Greyhound Racing Company Limited, of which Charlie Knott was a director and one of the principal shareholders, on 28 February 1928 for £13,800. The old house that had been Banister Court School was demolished, the lake filled in and the stadium opened for greyhound racing on 1 August. (Southern Newspapers Limited)

One

The Saints
Through The Years

The Birth of the Stadium

Southampton Greyhound Racing Company Limited was formed to operate the new Banister Court stadium, but after the initial interest, crowds for greyhound racing tailed off and the company's finances were precarious. Following the huge success of the dirt-track meeting organised by Jack Hill-Bailey at the King's Oak circuit at High Beech on 19 February 1928, venues opened up all over the country. There were two main organisations. The Australian, A.J. Hunting, formed International Speedways Limited with his Queensland contingent – Frank Arthur, Frank Pearce, Charlie Spinks, Hilary Buchanan, Dicky Smythe, Ben Unwin, Noel Johnson, Jack Bishop and Billy Lamont. The rival company, under the astute management of Jimmy Baxter, was called Dirt Track Speedways Limited, and they contracted Australians Paddy Dean, Irvine Jones, Billy Galloway, Keith McKay, Buzz Hibberd and Frank Duckett. There were also freelance riders like American 'Sprouts' Elder and New Zealander Stewie St George, who were very much in demand because of their exciting skills and could virtually name their own fees. New directors Bert Webbey and Ronnie Prideaux had seen the dirt-track meeting at West Ham put on by Jimmy Baxter and invited him to Banister Court. Jimmy liked what he saw and signed a lease for three years to put on dirt-track racing. The track was laid in about six weeks and the first meeting took place on Saturday 6 October 1928.

Two meetings a week, on Wednesdays and Saturdays, were held and the season did not close until well into November. The response was wonderful and the enthusiasm of the crowds even better. The opening meeting consisted of scratch and handicap races, the star event being a 'Special Match Race' between 'Sprouts' Elder and local man Ivor Creek. Other well-known names like Buster and Roger Frogley, Buzz Hibberd, Billy Galloway, Les Blakeborough, Alf Foulds and Southampton riders Vic Collins, Tommy Cullis, Jimmy Hayes and Ernie Rickman

also appeared in the 1928 season. It was now evident that dirt-track racing was to play as big a part in the life of the stadium as greyhound racing, so the step was taken of changing the name of the company to Southampton Sports Stadium Limited and Charlie Knott, together with Bert Webbey and Ron Prideaux, took more control of the company.

League Speedway

During the 1928/29 winter, Jimmy Baxter worried about the future of the game. It had started as an entertainment, yet to him it seemed that it could become a sport. The circus element could be eliminated for something more appealing to British sporting folk. It is said that while reading the soccer results one Saturday, he thought of the idea of a speedway league, with the word 'speedway' replacing 'dirt-track'. Jimmy was soon busy working out a scheme and eventually came up with a nine-heat event. He decided to try out his idea at Southampton, with a match against West Ham. He put his plan to the other promoters but got no support at all. However, Jimmy went ahead and invited all the management to attend the match at Southampton. None came, but the press took up the league idea to such an extent that when he staged the return at West Ham, nearly all the other promoters were there. The match was a big success. Never had there been so much excitement at a cinder meeting. Not all the promoters were convinced, but with more pressure from the press they had to concede and the League was born.

The Saints, as they were known, wore colours of Cambridge blue, and they finished just two points behind champions Stamford Bridge, in what was called the Southern League in that first 1929 season of league racing. They started the season well with a 41-22 home win in a challenge match against West Ham and skipper C.S. Barrow scored a 12-point maximum, when a race win was worth 4 points. Although losing their first two league meetings, the Saints then settled into a successful run, scoring home and away victories of 43-20 and 40-22 over Wembley, 45-18 and 37-26 over Wimbledon, 22-19 and 25-17 over Perry Barr and 48-15 and 33-29 over White City. They lost just four of their twenty league encounters. Both Jimmy Hayes and Tommy Cullis captained the side before suffering injury, and then Vic Collins took over the leadership. Other prominent Saints in 1929 were Clarrie Eldridge, Eric Lister, Ernie Rickman, Cecil Bounds, Col Stewart, Frank Bond and Albert Wakerley.

The first track record holder, American star 'Sprouts' Elder – winner of the Southampton Open Championship and the Golden Gauntlet in 1929 – was signed by Southampton for the 1930 season. He took over as skipper from the injured Vic Collins and Geoff Taylor, leading the team to second place in the table, six points behind champions Wembley. Double victories were achieved against Lea Bridge, Hall Green and West Ham, with the biggest win being the 40-12 defeat of Coventry in August. The leading scorers were newcomers Taylor, Frank Goulden and Australian Arnie Hansen, with steady support coming from Elder, Hayes, Lister, Eldridge, Bond, Rickman, Dick Sulway, Ken Purser and Vic Collins, before and after his injury. Collins recovered so well that he won the Golden Gauntlet in the last home meeting of the season.

The 1931 season saw the big signings of England star Jack Parker and his brother, Norman, from Coventry. Another newcomer was Australian Steve Langton. Jack Parker, who captained the team, scored sixteen maximums to finish top scorer, with Ernie Rickman close behind. There was good support from Norman Parker, Collins, Goulden, Bond, Hansen and Langton. Despite having the Parker brothers, the Saints dropped to seventh in the table, twenty-three points behind Wembley, who were champions again. Tom Bradbury Pratt joined Charlie Knott, Roger Prideaux and Bert Webbey as a director, and was a great showman.

A special company, Southern Greyhound Racing Promotions Limited, was formed to run greyhounds at Southampton with a totalisator. It was a huge success and greyhounds flourished at the stadium in 1932. The greyhounds were so prosperous that a London syndicate approached

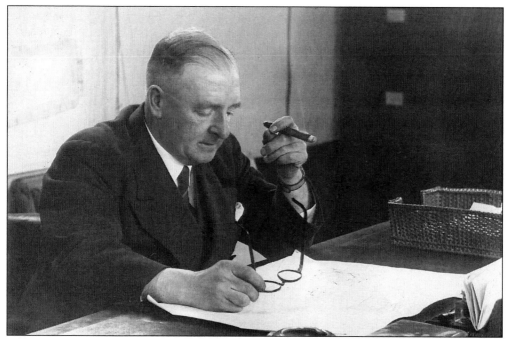

Born on 8 April 1891, Charlie Knott became a successful businessman in Southampton, with a passion for sport, and was an accomplished footballer. He was a director of Southampton Sports Stadium Limited, which put on speedway from 1928 to 1932. He reintroduced the sport to Banister Court in 1936 and was firmly established in the affections of the people of Southampton as 'Mr Stadium'. After the war, he took over promotion of speedway in 1952, until the stadium's closure in 1963.

the directors with a proposal that a public company, with a share capital of £100,000, should be formed. The deal was done, and all the assets of Southampton Sports Stadium Limited and Southern Greyhound Racing Promotions Limited, including the freehold of the stadium, were taken over by the new company, which was named Bournemouth and Southampton Stadiums Limited. Charlie Knott was unhappy with this development, and did not take a seat on the board, but he continued to be a shareholder.

Interest in speedway at Banister Court was declining. Charlie Knott moved the team to London in mid-season and operated from Lea Bridge. They were called Clapton and again had Jimmy Baxter in charge. Before the move, the Saints had only won three of their eleven league matches, with Ernie Rickman top scoring. Jack and Norman Parker, Vic Collins, Wally Lloyd, Frank Goulden and Steve Langton were the other regulars and injury prevented new signing Phil Bishop making any impact.

Charlie Knott was told to keep away from Banister Court, but he was not happy with the way things were being run. Totalisators had been declared illegal, but the company ignored this. After a police raid on the stadium, the tote was closed down. This legal decision proved to be a blow from which Bournemouth and Southampton Stadiums Limited was unable to recover. In 1934, with the passing of the Betting and Lotteries Act, the situation changed completely and it looked as if greyhound racing might be financially successful again. Charlie Knott, as a principal shareholder, was instrumental in the stadium returning to local control. A new company was formed – Southern Sporting Promotions Limited – with Charlie Knott as managing director. He ran the stadium so successfully that, by 1936, it was possible for them to buy the freehold from the moribund public company for £43,000.

Mention should be made of Tom Bradbury Pratt. T.B.P. or 'Long Tom' as he was known, was

well over six feet tall and, being thin, looked even taller. Charlie Knott met him at Liverpool greyhound track in 1931 and invited him to join Southampton Sports Stadium Limited as a director. T.B.P. and Charlie became close friends and were known as the 'long and the short' of the stadium. Bradbury Pratt was also a reckless gambler. Charlie had a more moderate approach, and one was the perfect foil for the other. After the move to Lea Bridge in 1932, Charlie and T.B.P. formed a new company, North London Speedways Limited, and in 1934 ran speedway at Harringay, together with Roger Prideaux, the Thompson brothers and Tom Draper. They also organised meetings at Birmingham and Portsmouth, but the main emphasis of their efforts was the resurgence of the Saints at Banister Court. Another important addition to the company around this time was Charles Foot, an accountant who eventually became Company secretary and worked closely with the Knott family right up to the 1970s.

National League Division Two (Provincial League)

Much to Charlie's delight, speedway racing had now recovered its popularity and it was an economic proposition to restart the sport in Southampton. In October 1935, two challenge matches were held at the stadium, with Belle Vue beating Wembley 57-51 and Harringay beating West Ham 37-35. The 1936 season saw the Saints in the Provincial League, wearing red and white. They were captained by old favourite Frank Goulden, who, with Australian Bert Jones, finished close behind leading scorer, Sid Griffiths. Charlie Knott used his Harringay connections to bring in Griffiths and other regulars – Fred Strecker, Billy Dallison, Harry Lewis, Alec Statham, Art Fenn, Bob Lovell and Cyril Anderson, as well as former Australian Test star Dicky Smythe, who contributed useful points in three league appearances. In a thrilling conclusion to the season, Southampton beat Bristol to clinch the championship, and they also won the Provincial Trophy.

In 1937, the rivalry with Bristol was resumed, but this time the Bulldogs won the league championship and the Saints were runners-up. Goulden captained the side and was leading scorer. Dallison, Griffiths and Jones gave excellent support and Vic Collins appeared regularly again after just one league outing in 1936. Newcomers Jack Hobson and Jack Riddle scored well, as did Anderson. Jim Boyd had his first season with the Saints, and pioneer rider Ivor Creek made his debut for his local team, missing only two league matches.

Southampton were desperate to regain their premier league status and were not happy that Bristol were promoted in the 1938 season, while they were not. This time they finished third, behind champions Hackney Wick and Norwich. They were once again led by Frank Goulden, who top scored. Ernie Rickman came out of retirement and had a successful season, as did Dallison, Griffiths and Jones. Alf Kaines joined from Lea Bridge and Charlie May and Mike Erskine made their first appearances. Australian Frank Dolan and Ron Howes had a few rides and Jack Parker reappeared for the Saints in a challenge match against First Division Belle Vue. In a new competition for the Second Division sides called the English Trophy, Southampton won the Southern section and met Belle Vue Reserves, the Northern section winners, in a final over two legs which Belle Vue won on aggregate 85-82.

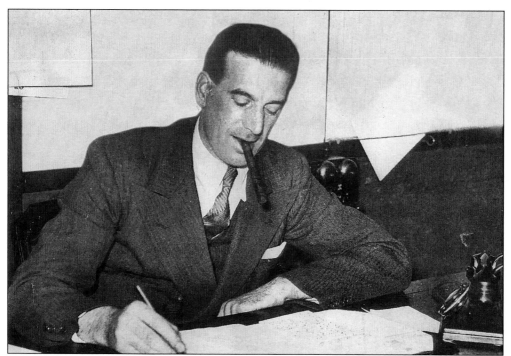

Tom Bradbury Pratt, who joined Southampton Sports Stadium Limited as a director in 1931, became close friends with Charlie Knott. He was a familiar figure around the speedways and was well known for his long cigar and genial grin. Sadly, he died just before Christmas 1938, at the age of just thirty-nine.

Promotion

The 1939 season started on a high note, with Southampton at last promoted to Division One of the National League. Charlie Knott brought in two top Americans to strengthen the side. Ironically, Bristol had decided not to race in the First Division, which meant American ace Cordy Milne, who was third in the 1937 World Final, had to be reallocated. He joined the Saints, together with Wimbledon rider Benny Kaufman. Goulden was again captain and, together with the two Americans, the regular line-up featured Dallison, Griffiths, Jones, – who had his bike stolen in May – Kaines and Boyd. Former big stars Gus Kuhn and New Zealander Wally Kilmister had a few outings without success. An interesting feature of the season was the change in colours, from red and white to blue and white squares, at the beginning of May. Wembley, who wore red and white, were starting their fixtures and it was decreed by the ACU that the Banister Court outfit would have to change. Cordy Milne was outstanding and the Saints' top scorer, followed by skipper Goulden and Kaufman. Milne also was the top qualifier for the World Final and a clear favourite for the title. Fellow American Kaufman also reached the last stage and Goulden was a reserve. Unfortunately, due to the outbreak of the Second World War, the final was not held and league speedway was abandoned, with the Saints just above New Cross at the bottom of the table.

In order to keep up the morale of the British people, some wartime sporting events were held and in 1940 three tracks managed to hold speedway meetings. They were: Belle Vue under the promotion of Mr Spence; West Ham with Johnny Hoskins in charge; and Southampton

with Charlie Knott directing operations. Two meetings were put on at Banister Court over the Easter weekend. The first one, on Good Friday, was for the 'Sprouts Elder Trophy'. It was won by Harringay's Jack Parker with a 15 points maximum, and Saints' skipper Frank Goulden was runner-up with 14. The second meeting on Easter Monday, again held in the afternoon because no lights were allowed, was a challenge match between Southampton and a strong Harringay side. Harringay won 62-46, with Jack Parker again getting a 15-points maximum. Goulden top-scored for the Saints with 9. These meetings were the only ones held at Banister Court until the war was over and normal service was resumed.

Post-war Boom

On Tuesday 29 April 1947, the tapes went up at the first speedway at Banister Court since 1940. Southern Speedways Limited leased the track from stadium owner Charlie Knott, and with Jimmy Baxter at the helm once more, ran speedway from 1947 to 1951. The Saints rode in the new National League Division Three, and led the table for much of the season, eventually finishing third – one point behind champions Eastbourne and runners-up Cradley Heath. Pre-war captain Frank Goulden, unable to ride because of the rule that no ex-Division One star rider could ride in Division Three, was given the job of team manager to build a side. Local grass-track youngsters Bob Oakley (who had had a little experience at New Cross in 1946), Jim Squibb and Bert Croucher – together with Wimbledon juniors Peter Robinson and George Bason, and pre-war Saints Vic Collins and Alf Kaines – formed the basis of the line-up. Promising rider Pete Lansdale joined in June and Vic Collins, who captained the Saints in 1929 and 1930, was made skipper and was always ready to help and advise the team. Peter Robinson was the best rider and a prolific scorer, despite missing several matches through illness and injury. Bob Oakley, for whom the Saints paid New Cross £25, as ordered by the SCB, was a heavy scorer, as was Jim Squibb. Leg-trailer Bason provided the spectacle and Croucher, Lansdale and Bill Griffiths all showed promise. Matt Hall looked one of the best prospects, but never recovered from his early season injury. Ernie Rawlins, a future captain of the Saints, made his debut in the Knock Out Cup in September. The return of speedway to Banister Court was a great success and the future looked bright.

Peter Robinson was signed by First Division champions Wembley for the 1948 season but, due to ill health, he moved back into Division Three with Plymouth – who were also run by Southern Speedways Limited. Alf Bottoms came from Wembley to replace him and was almost unbeatable on Third Division tracks, scoring a massive total of points. Squibb and Oakley scored well and Bob's older brother, thirty-seven-year-old Tom, was a useful addition to the team. Another newcomer, Cecil Bailey, was outstanding and won the Speedway World 'Novice of the Year' award, but Croucher missed half the season through injury. Bason and Kaines had the occasional high-scoring meeting before Kaines, too, was injured. The Saints again finished third in the league, but were beginning to look too strong for the Third Division.

The 1949 season saw Southampton promoted to Division Two, with Bottoms returning to Wembley in exchange for Roy Craighead. The new captain, Bob Oakley, was the big star, and Squibb, Bailey, Craighead and Tom Oakley scored well and ensured the Saints a respectable, middle-of-the-table position. Bason and Croucher stayed in the Third Division with new teams Liverpool and Oxford, while Kaines struggled at the higher level. Pre-war Saint, leg-trailer Bishop, returned to provide some thrills for the Banister Court faithful and young New Zealander, Bill Thatcher, looked like one for the future, as did Griffiths. Australian Bill Rogers' comeback was not a success and he only rode in a handful of matches.

Entertainment Tax and Closure

Bad weather dominated the 1950 season, which saw several team changes. Cecil Bailey moved to Plymouth and Southampton recruited pre-war Saint, Steve Langton from Tamworth, Les Wotton from Coventry and Buck Whitby from Birmingham. Gates were low and the loyal fans were upset when Bob Oakley went to Wembley in July for a record Second Division fee of £1,500. However, he deserved his chance in the senior league and the management needed the money. Jim Squibb took over the captaincy and battled for the top scorer's spot with Roy Craighead and Tom Oakley. Kaines and Griffiths moved into Division Three with Exeter and Liverpool and Bishop faded from the scene after injury. Things looked brighter when Bailey returned in August and local youngster Bill Holden looked an exciting prospect. Former Hastings rider Harold McNaughton also fitted in well when he joined late in this somewhat turbulent season, and to finish in the top half of the table was quite an achievement.

Poor crowds and the crippling entertainment tax combined to make for a bleak 1951. To his credit, Jimmy Baxter tried everything. He and all his staff took a fifty per cent cut in salary, and landlord Charlie Knott halved the rent, but money seemed to be tight everywhere. Crowds were well under the 6,000 break-even requirement, and the riders did not help matters by refusing to take a pay cut when everyone else involved had. Even a race night change from the traditional Tuesday to Friday and back again failed to make a difference. On the track, former Saint Bert Croucher came out of retirement and another local man, pre-war Saint Charlie May, joined from Walthamstow. Tom Oakley, Squibb and Craighead continued from where they had left off the previous season, but it wasn't on the track that the problems lay. A crowd of around only 2,000 saw the Saints' big 57-27 win over Hanley in June, so Jimmy Baxter withdrew his team from the league immediately after the match. A week later, a team of ex-Saints rode against the current team. At the end of the meeting, Charlie Knott, the owner of the stadium, promised fans that there would be speedway again in the near future. He was a man of his word and there was to be a new beginning for Southampton Speedway at Banister Court Stadium.

The Saints Live Again

Southampton Speedway reopened on Good Friday, 11 April 1952. Nearly 8,000 spectators saw the Saints beat Long Eaton 57-27 – curiously the same score as the last league match before the 1951 closure – in the new Southern League, on a new cinders track in new race jackets of red and white stripes, with reduced prices and a new promoter, Charles Knott, the managing director of Southern Sporting Promotions Limited. After holding trials for dozens of aspiring speedway riders, the new Saints took to the track with former Saint Bert Croucher leading the side. Many riders were tried, most without success, and results were disappointing, but the crowds still came and a great discovery was made in New Zealander Brian McKeown, who topped the scorecharts at the end of the season. Youngsters Maury Mattingly and Dudley Smith showed flashes of brilliance, Smith capturing the track record. Novice Jack Vallis included a maximum in his total of 64 points in 26 matches, and Mike Tams and Ernie Brecknell won the hearts of the fans with their wholehearted efforts. Pre-war Saint Mike Erskine took over as team manager, and although the wooden spoon was only avoided by winning the last match, a more settled future looked assured.

Charlie Knott's determination to put on a good show at Southampton in Coronation Year was reflected when crowds again increased in the 1953 season. An attractive stadium deserved an impressive team, and former Saints' novice Ernie Rawlins returned from Oxford, taking

over as captain from the retiring Croucher. Rawlins topped the league scorers and McKeown, Brecknell and Mattingly gave good support. Smith and Tams would have scored more but for injuries. Hugh Geddes did well after joining the Saints when Cardiff closed, but the rider who caught the eye was local youngster Brian Hanham, who won the Speedway World 'Novice of the Year' award. McKeown suffered a severe leg fracture at Poole in September, but fortunately the team only had one more match to ride. A mid-table position was a big improvement on the previous season.

The Saints joined the newly-formed National League Division Two in 1954 and Ken Adams, John Fitzpatrick, Charlie May, Gerald Pugh and later Jack Mountford were signed in an attempt to bring the Saints up to Second Division standard. The team struggled on away tracks, losing every match. Although he top-scored, McKeown was not the force he had been, and May and Fitzpatrick were the most consistent of the newcomers. Mattingly started the season well, but faded badly and Brecknell got injured, fell out of favour and missed a lot of matches. Southampton badly needed a regular double-figure scorer. Skipper Rawlins got the occasional high score at home, but it was a mystery why the track record holder, Smith, only had one outing in the Saints' colours. After a slow start to the season, Hanham improved, thrilling the fans with his exciting style and looking like a star of the future. A poor third from bottom spot was all that was achieved, but three more wins would have lifted the Saints to the runners-up position.

1955 saw Southampton get the double-figure scorer they lacked in the previous season. In the face of competition from all the First Division clubs, promoter Charlie Knott captured the signature of England international Dick Bradley when Bristol closed in June. He quickly settled at Banister Court and was a prolific points gatherer. Rawlins had a good year and Hanham became one of the best riders in the league. Popular favourite McKeown did not return from New Zealand and Adams, Brecknell and Pugh went to Weymouth. The new signings, Australians Bluey Scott and Allan Quinn, had a mixed season, with Scott moving on to Ipswich and Quinn missing many matches with injuries. Mattingly was another who was unlucky with injury, which gave ex-Ringwood youngster Alby Golden an opportunity. May rode with his usual consistency and Fitzpatrick was surprisingly allowed to go to First Division West Ham in August. By the end of 1955, it was felt at Banister Court that the club was in a good position to make even more progress.

In 1956, the Saints were unbeaten at home and were pipped to the Second Division title by Swindon by one point. Bradley was brilliant and, together with Rawlins and Hanham, formed a very strong heat leader trio. Golden, Mattingly and ex-Bristol rider Johnny Hole all made worthwhile contributions, while former Saint Bill Holden was signed from neighbours Poole and filled the gap when May retired. Ably led by new team manager Bert Croucher, the Saints were a powerful combination and exciting to watch. As a result, crowds were good. Tragedy struck at the final home meeting, when skipper Rawlins crashed and was rushed to hospital with head injuries from which he died four days later. His passing took the shine off what was an otherwise successful season. The popular Rawlins would be much missed both on and off the track but, once again, Charlie Knott was to produce yet another masterstroke before the start of the next season.

England's Test Captain
Signs for the Saints

1957 was an unhappy year for speedway, with only eleven teams running in the one league, seven of which had been in Division Two the previous year. The greatest post-war side, Wembley, had closed and Charlie Knott pulled off a major signing by persuading former Wembley Lion Brian Crutcher, England's Test captain, to ride for the Saints. The fans responded by turning out in their thousands to watch a most attractive and exciting team. Dick Bradley replaced the late Ernie Rawlins as captain and led by example. He had a brilliant season, finishing as top scorer and forming a potent spearhead with new signing Brian Crutcher. Crutcher was almost unbeatable and made speedway racing look very easy. Hanham and Golden provided the thrills, backed by old favourite Jim Squibb – who had returned to Banister Court – Holden and Hole. Mattingly started the season well, but missed a lot of matches through injury. The team deserved more than the mid-table position in which it finished.

In 1958, the Southampton team was strong enough to be able to release Mattingly to Coventry and Holden to Poole. Former England International 'Split' Waterman was signed and Australian Chum Taylor returned to England after several years' absence. At first, it looked as if the Saints would win everything and with increased attendances, the atmosphere at Banister Court was good. Three Test matches were staged, with Crutcher, Bradley and Squibb representing England and Taylor appearing for Australasia. Crutcher was injured in the first month of the season, but came back stronger than ever and won the Golden Helmet. Waterman retired in June and Hanham missed some matches through injury, but Squibb had a good season, as did Taylor. Johnny Hole gave his usual sound support and the Saints gave first opportunities to future world finalists Leo McAuliffe and Brian Brett. A third placing in the league and semifinalists in the National Trophy was no less than the entertaining Saints deserved.

Southampton won nothing in 1959, but were now recognised as one of the top speedway clubs in the country. Charlie Knott made yet another significant signing by getting New Zealander Geoff Mardon to come to Banister Court. Wimbledon were not happy with this, as they claimed that Mardon still belonged to them. However, the SCB upheld Knott's right to make the signing. Mardon was a huge success, but suffered a fractured jaw in July. Charlie Knott delivered a further masterstroke by signing the young Swedish sensation Bjorn Knutsson to replace the injured Mardon, and managed to retain him when Mardon recovered. He recovered enough to reach the World Final, as did Brian Crutcher, who top-scored despite missing several matches in May and June. Crutcher had a somewhat controversial season. He was still scoring as well as ever, but speedway was not necessarily his top priority, and he found it difficult to combine his racing with running his motor business. Skipper Bradley did well considering the bad injuries he sustained riding for England in Poland in the close season. Australian Jack Scott did not live up to his reputation and Squibb moved back to Poole during the season. However, the Saints always looked a class outfit, and with Hanham, Golden and now the young Brian Brett providing the dash and daring, the Banister Court fans were very happy.

By contrast, the 1960 season was a catalogue of disasters for Southampton Speedway. Mardon did not return from New Zealand and Crutcher, still scoring heavily, retired in May. Hanham came out of retirement to ride in half a dozen matches. Taylor broke his wrist, but recovered well to ride in the World Final. The new Swedish rider, Alf Jonsson, badly broke his leg after only two outings. Charlie Knott then signed another Swede, Olle Nygren, who was a great success, finishing as the Saints' second highest scorer behind the brilliant Knutsson. Part of the main grandstand was destroyed by fire and loyal skipper Bradley rode on, despite suffering problems with his injured wrist. He was an ever-present, as were Golden and Scott, who still

did not score the points expected. Brett and Hole moved on, but Peter Vandenberg looked promising. 1960 was probably a year that the Saints' management would want to forget but, true to form, Charlie Knott was to make another important signing for Southampton Speedway.

National League Champions

The efforts of promoter Charlie Knott were rewarded in 1961, when the Southampton speedway team won the National Trophy, the Knock Out Cup, and finished second in the league, two points behind champions Wimbledon. The important signing he made to transform his entertaining side into a trophy-winning one was that of former World Champion Barry Briggs. Once again, Charlie Knott acted while other promoters were still pondering and, for £750, Briggs became a Saint. He and Knutsson were unstoppable, and another good signing was that of former England star Cyril Roger, who had a new lease of life at Banister Court and scored steadily. Taylor was unlucky with injuries and Bradley was not such a big scorer as he had been in other years. Without question, the Saints would have been league champions if they had not loaned out Jack Scott to Plymouth. After a big pools win enabled him to improve his equipment, Scott at last realised the potential everyone had said he had. He was almost unbeatable in the Provincial League and reached the British Final of the World Championship. He also scored well when he turned out for the Saints and Charlie Knott desperately tried to get him back, but the SCB would not allow it. This cost Southampton the League Championship. Nevertheless, they had an excellent season. Individual success came to Knutsson, who was Match Race Champion, Swedish Champion, and runner-up to Fundin in the World Final. Briggs won the British Final at Wembley and was fourth in the World Final.

1962 was the season that Handicap Racing was introduced and despite the Saints' big two, Briggs and Knutsson, being back markers, Charlie Knott finally achieved his ambition of leading a team to the major prize as the Saints romped away with the League Championship. Keeping free of injuries helped, and Peter Vandenberg and Alby Golden had an excellent season. New signing Reg Luckhurst looked good until he was injured, and old favourite Brian Hanham came out of retirement to ride in three matches. Taylor and Scott did not return from Australia, but the Saints didn't need them as Cyril Roger again performed admirably. Individually, the positions were reversed from the previous year, with Briggs being runner-up to Peter Craven in the World Final and Knutsson finishing in fourth place. The Saints fans were euphoric about their team's success and could not be expected to foresee how different the situation would be twelve months later.

Everything went wrong for Southampton speedway in 1963. They still had two of the top riders in the league in Briggs and Knutsson, but they were not allowed to have Chum Taylor back after he had missed the 1962 season. He was allocated to Oxford because Southampton were said to be too strong. Skipper Bradley had a bad injury at Exeter in June and did not ride again. The balance of the side was upset and the team never recovered. Even old favourite Brian McKeown, who was signed as injury cover, got badly hurt and only rode in a couple of matches. Cyril Roger was a sick man and Luckhurst, Golden and Vandenberg had a poor season. The spirit seemed to have gone out of the side and they finished next to bottom. However, there was some success, as the Saints won the Knock Out Cup and, individually, Knutsson and Briggs finished second and third in the World Final. But it had been decided that Banister Court Stadium was to be sold to the Top Rank Organisation so, on a rain-swept Thursday 3 October, the last meeting – which had been postponed from Tuesday 1 October – took place. It was a sad occasion and it was difficult to believe that the sound of speedway bikes would no longer be heard on this famous track, where so many of the top stars of speedway had once been seen.

Two

1928-1940

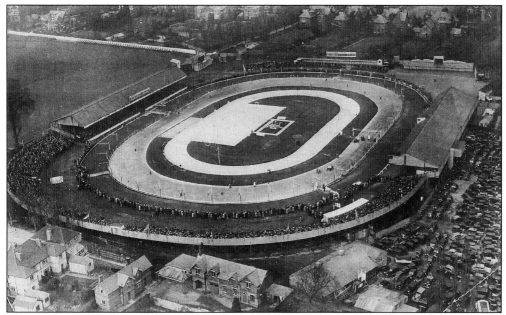

Banister Court Stadium, 1939. Riders, officials and rakers can be seen on the speedway track. The outer circuit is the greyhound track. The white inner circuit was used for roller-skating and the white rectangle for roller-hockey and tennis. The field on the left is the County Ground, home of Hampshire cricket.

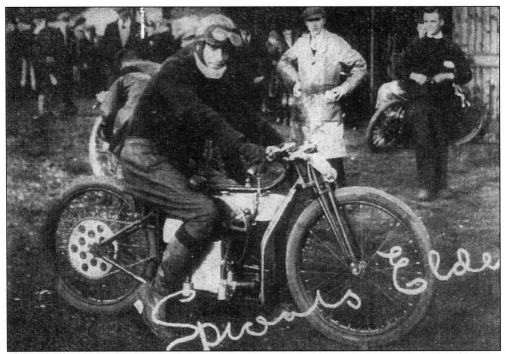

The star attraction at the first dirt-track meeting at the stadium on 6 October 1928 was the American 'Sprouts' Elder, who had excited crowds all over the country with his daring broad-siding. (*C.F. Wallace*)

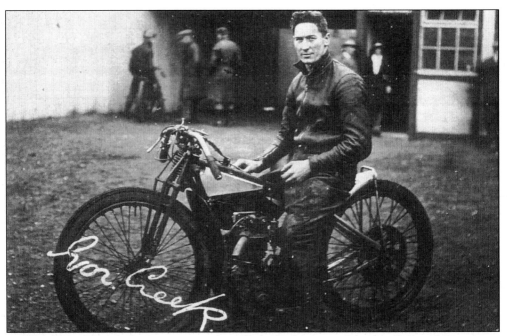

Ivor Creek was a Southampton motor cyclist who had taken part in the first dirt-track meeting at High Beech on 19 February 1928. He was chosen to ride in a special match race against 'Sprouts' Elder in the first meeting at Banister Court. (*C.F. Wallace*)

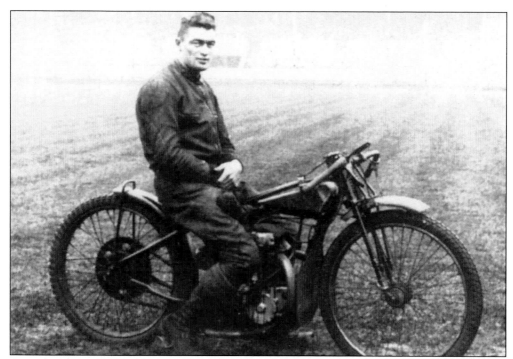

Australian Buzz Hibberd was contracted to Jimmy Baxter's Dirt Track Speedways Limited, and appeared many times at Southampton in 1928. He rode for Baxter's West Ham team when league racing started in 1929.

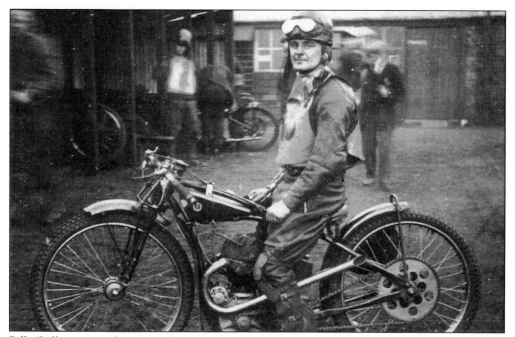

Billy Galloway, another Australian, and known as the 'Demon Barber' because of his occupation, rode in the first meeting at Banister Court and was almost unbeatable at Jimmy Baxter's track at Celtic Park, Glasgow. (Wright Wood)

Buster Frogley appeared regularly at Southampton in 1928 and was the first captain of Wembley when they formed a team in 1929. He also rode in their championship-winning teams of 1930 and 1931.

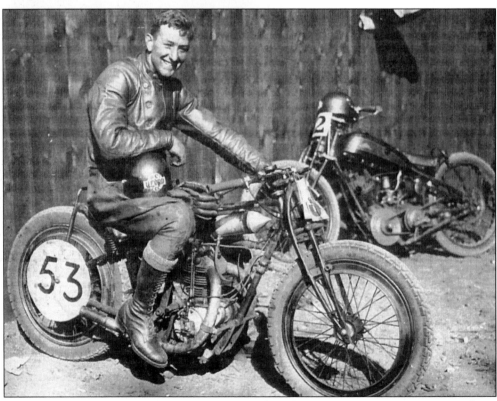

Roger Frogley had many exciting duels with 'Sprouts' Elder at Banister Court in 1928 and was the first ever British Star Riders Champion in 1929. He later rode in the league for Crystal Palace and in test matches for England.

Left: Although Tommy Cullis was born in Coventry, as a speedway rider he was a product of Banister Court and was prominent in the 1928 season. He captained the Saints in 1929 after Hayes' injury. *Right:* Former public schoolboy Jimmy Hayes broke 'Sprouts' Elder's track record and took over the captaincy of the Saints from C.S. Barrow in 1929 before he was injured.

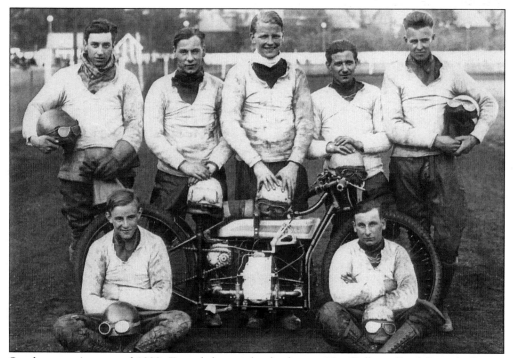

Southampton's team of 1929. From left to right, back row: Vic Collins, Cecil Bounds, Jimmy Hayes (captain), Jimmy Pink, Clarrie Eldridge. Front row: Eric Lister, Tommy Cullis.

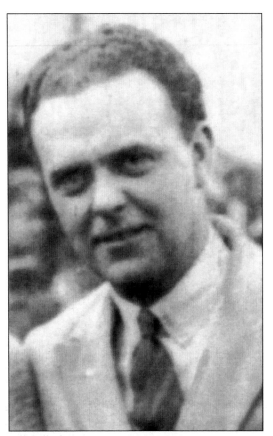

George 'Jimmy' Baxter was an accomplished hill-climb and trials rider and was also the chairman and secretary of the Metropolis Motor Club. After hearing about the success of dirt-track racing in Australia, he contacted Jack Hill-Bailey, the secretary of the Ilford club, about putting on a meeting in England. A track at High Beech in the South East area was found and the Ilford club got the licence to run the original show in February 1928. Jimmy opened Celtic Park, Glasgow in April, moving his organisation to West Ham in July. He opened Southampton in October and was also the one who initiated competitive team racing and the formation of the Southern League in 1929.

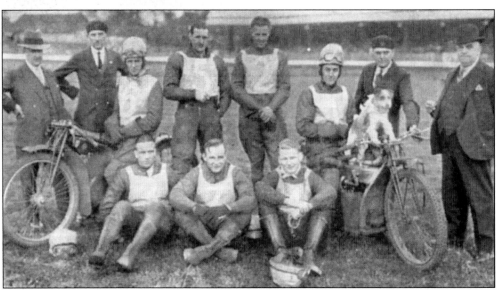

Southampton's team, 1930. From left to right, back row: Charlie Knott (director), H.W. Rawnsley Gurd (machine examiner), Ken Purser, Geoff Taylor, Clarrie Eldridge, Vic Collins (captain) and Buster (team mascot), Jimmy Baxter (promoter), Bert Webbey (director). Front row: Frank Goulden, Eric Lister, Jimmy Hayes.

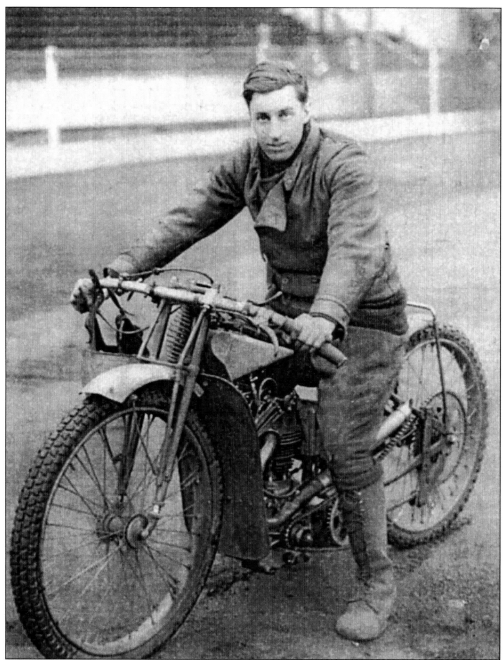

Saints star number one – Vic Collins. Collins was born at Titchfield, Hampshire, on 19 September 1905. He rode at the first meeting at Banister Court and captained the Saints in 1929 and 1930, before breaking a leg. He returned to win the Golden Gauntlet in the last meeting of 1930 and was a regular for the next two seasons, moving with the team to Lea Bridge. After a break from racing, he had a couple of outings in 1936 before riding regularly again the next year. Collins retired after a few weeks in 1938, but returned to the saddle to captain the Saints in 1947, their first season after the war. Most particular about machinery, he was always ready to help colleagues and was a most loyal team man. (*Hampshire Advertiser*)

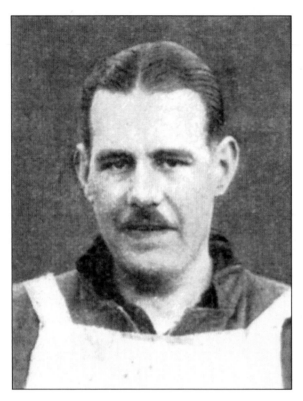

Geoff Taylor rode at the first meeting to he held in the North of England at Audenshaw, Manchester, in March 1928. An all-round motorcyclist, he rode for Halifax in the Northern League in 1929 and made his first visit to Banister Court on 28 September, marking the occasion by breaking the track record. The Saints secured his signature for the 1930 season, and he proved to be a very valuable member of the team. Taylor captained the side for a while until he was injured but, despite missing a few matches, he still finished as the top scorer.

During the first few seasons of league speedway at Banister Court Stadium, the team mascot was a dog called Buster, who had the unusual ability to write letters and articles. Here is one of his literary efforts, which was published in the 1930 season.

Southampton's Mascot

"A DOG'S LIFE."

By "BUSTER," the Team Mascot.

"Bow-wow everybody."

"Some guy has asked me to put him wise about this mascot business. Pardon my 'Murican, I've picked that up talking to 'Sprouts'."

Well, of course, I am jolly proud to be the mascot of the Southampton League Team, and I like to think that I bring them luck. Of course, I attend all matches home and away, and when the boys lose I am afraid I take it rather badly and my tail is very much down.

What's that? Do I mind riding on the motor round the track? Mind? Look here, do you think I bark with delight and wag my spot of tail until it nearly falls off if I mind. 'Course not. Perhaps I should confess that I would much prefer to chase the bikes, but there, what dog wouldn't? But to suggest that I am scared is altogther wrong.

In the first place I have been brought up among motors. When I was quite young I was given to my master, who is, as you know, Tommy Cullis, as a wedding present. I am very well bred you know, my father was a champion, and I have already had success on the show bench. Someone offered Tommy £100 for me the other day but Tommy said "Nuthin' doin'." Good old Tommy!

As I was saying I have been brought up among motors from early puppy-hood, and ever since I became a member of the Cullis family I have been around with motors of one kind or another.

When I go round on the bike in the Grand Parade, and how proud I am then, Vic Collins holds me mighty tight and although I jump about a bit with excitement I am in no danger of falling off, Vic sees to that. He's a good chap, too. Trust a dog to know a good fellow when he sees him.

Of course, I first went round with master and I hope I shall again some day. Although I am quite happy with Vic who is jolly clever at managing his bike with one hand whilst I am wriggling about, I am afraid over excitement is one of my little failings.

Then, of course, there is my mistress. She's a good sort too. Knows quite a lot about dogs, bred 'em in fact. She wouldn't let me go on the bike if she thought I didn't like it.

I saw a bike doing nothing the other day and just hopped up, and when the master and mistress saw me they did laugh, and I am not yet sure whether they thought I was a clever dog or whether they were just laughing at me because I looked silly.

I think Speedway racing is a great game, and, of course, like you, I want "my team" to win the League.

Cheerio folks!

Bow-wow."

BUSTER.

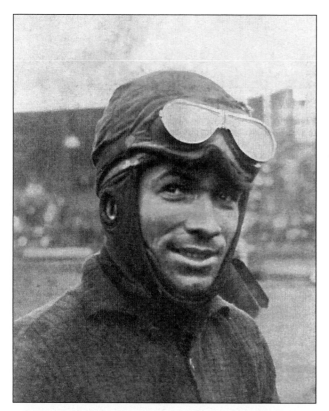

Lloyd 'Sprouts' Elder was born in Fresno, California, on 4 August 1904. He became the acknowledged hill-climbing champion of America, before turning his attention to dirt-track racing. 'Sprouts' opened the Banister Court track with an exhibition ride on 6 October 1928, and was the first track record-holder. He won the Southampton Open Championship and the Golden Gauntlet in 1929, and was a big capture for the Saints in 1930. While perhaps better suited to individual races, he was a popular team member and took over the captaincy from the injured Geoff Taylor. (*Speedway News*)

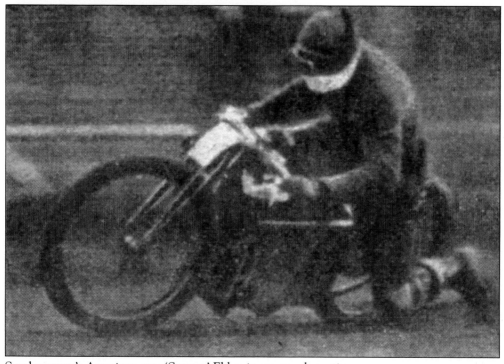

Southampton's American star, 'Sprouts' Elder, in spectacular action.

Another Saints' line-up in the 1930 season. From left to right: Eric Lister, Frank Bond, Arnie Hansen, 'Sprouts' Elder (captain), Jimmy Baxter (promoter), Ernie Rickman, Vic Collins and Buster (team mascot), Jimmy Hayes.

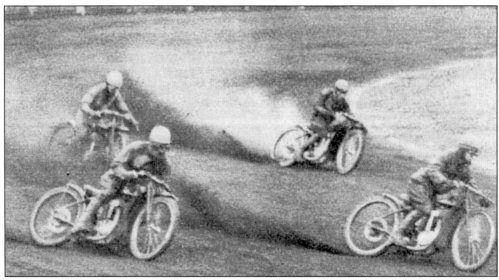

The first heat of the league match between Coventry and Southampton at Brandon on 29 May 1930, which marked 'Sprouts' Elder's debut for the Saints. From left to right: Clarrie Eldridge, Jack Parker, 'Sprouts' Elder and Wilmot Evans. Elder won the race after Parker had machine trouble, with Evans beating Eldridge for second place. Elder finished with six points from two victories. (*Speedway News*)

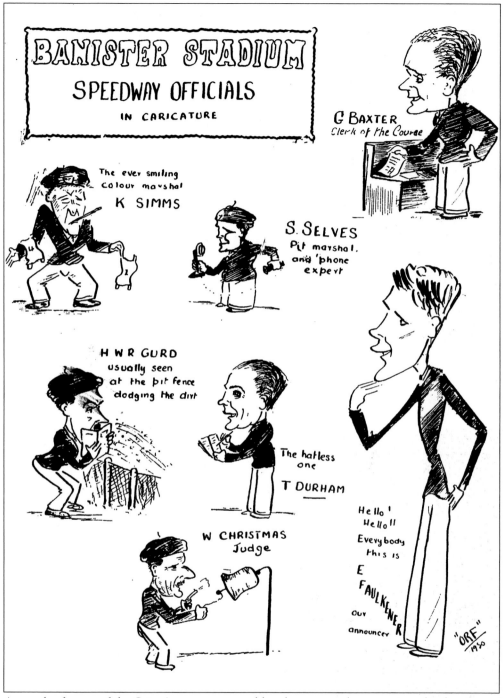

A popular feature of the Saints' programmes and brochures over the years were the drawings of 'Orf'. Here he accurately depicts the stadium officials of the 1930 season. (*Southampton Speedway Handbook*, 1930)

THE BRITISH
SPEEDWAY
CHAMPION

Jack Parker

Winner of the British Championship 1931, and Captain of the Southampton Speedway Team.

Jack Parker was born in Birmingham on 9 October 1905, and in the seasons 1928, 1929 and 1930 he rode virtually as a freelance – although for two years he was a member of the Coventry side. He then signed his first speedway contract for Southampton, for which he was reputed to have received sums varying from £100 to £2,000, and was appointed captain. He won the British Championship in 1931 and was a challenger for Vic Huxley's Individual Championship. Parker won at Southampton, and in the return at Wimbledon, Huxley won two heats and the other was a dead heat. The track record was broken in each race.

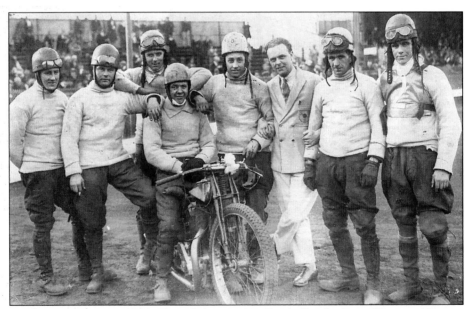

Southampton's team, 1931. From left to right: Frank Bond, Arnie Hansen, Norman Parker, Jack Parker (captain, on machine), Vic Collins, Jimmy Baxter (promoter), Ernie Rickman, Frank Goulden. (*Southern Newspapers Limited*)

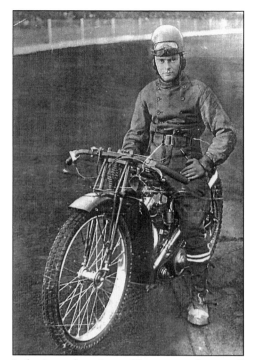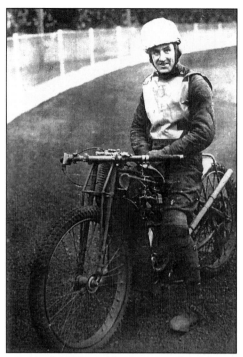

Left: Australian Arnie Hansen was born in Perth on 2 April 1907, and had two good seasons at Banister Court, in 1930 and 1931. *Right:* Londoner Frank Bond was born on 11 July 1904 and first appeared on a speedway track at Lea Bridge in September 1928. He rode for the Saints in 1929, 1930 and 1931. (*Hampshire Advertiser*)

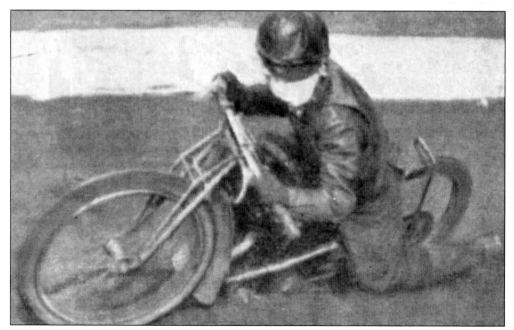

Arnie Hansen riding in his customary flat-out style at Banister Court, where he was a big favourite with the supporters.

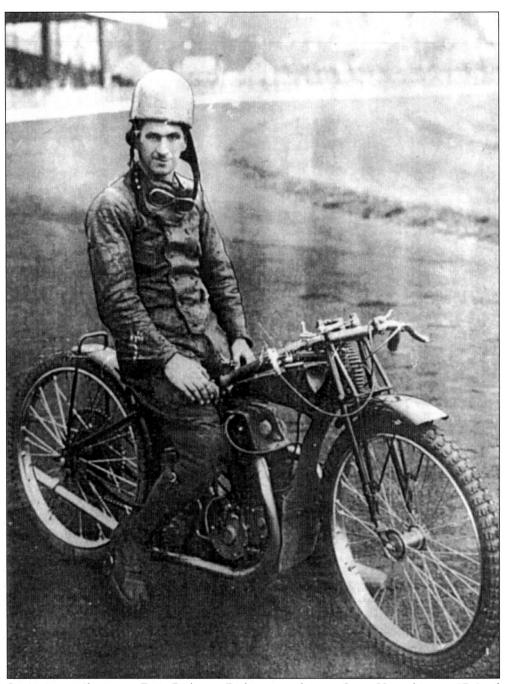

Saints star number two – Ernie Rickman. Rickman was born at Sway, Hampshire on 17 April 1903, and began his speedway career at Banister Court in November 1928. He rode several times for the Saints in 1929 and 1930, but really came into his own in 1931, when he was second highest scorer behind Jack Parker. He top-scored in the league matches at Southampton in 1932, before the team moved to Lea Bridge. An all-round motorcyclist, he quit the cinders, but came out of retirement and had an excellent season in the 1938 Saints line-up. Rickman appeared a couple of times in 1939 on the Saints' return to the top flight. (*Hampshire Advertiser*)

Norman Parker was born in Birmingham on 14 January 1908, and was always somewhat in the shadow of his brilliant older brother. Norman followed him into speedway and was an immediate success as a second string to Jack in the Coventry side. He also signed for Southampton in 1931, where he continued to ride as the partner to the Saints' captain. He was just behind top scorer Ernie Rickman in 1932, before the move to Lea Bridge. Norman then moved on to Harringay with his brother Jack, continuing under the management of Charlie Knott and Tom Bradbury Pratt.

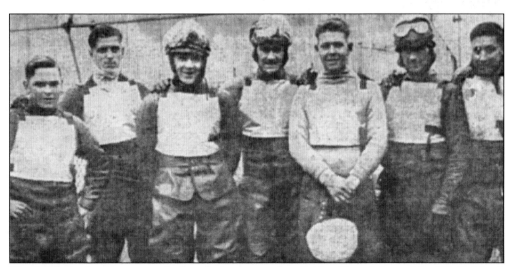

The 1932 Southampton team before their move to Lea Bridge. From left to right: Wally Lloyd, Norman Parker, Ray Taylor, Steve Langton, Jack Parker (captain), Ernie Rickman, Vic Collins.

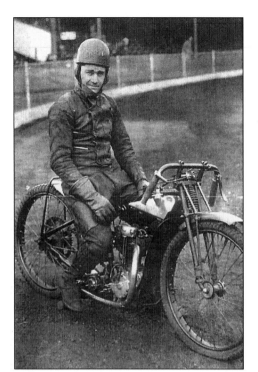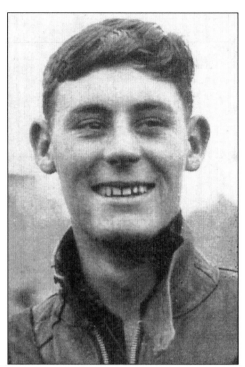

Left: Australian Steve Langton was born in Queensland in 1909 and rode for the Saints in 1931 and 1932. (*Hampshire Advertiser.*) *Right:* Phil Bishop was born in London in 1912 and was one of the most spectacular riders in the early days of the sport. He rode for Lea Bridge and captained the successful High Beech side before joining Southampton in 1932. Both riders returned to Banister Court a few seasons after the war.

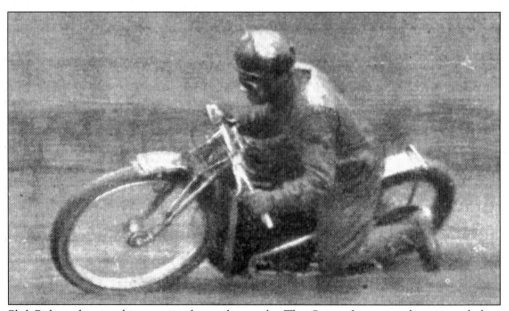

Phil Bishop showing his exciting leg-trailing style. The Saints fans were disappointed that, because of injury, he was confined to just three appearances for their team, in 1932.

4ᴰ

OFFICIAL PROGRAMME of the 1st Meeting

GOOD FRIDAY, April 10th 1936 at 3 p.m.

SOUTHAMPTON

SPEEDWAY

Banister Stadium, Banister Court, Southampton.

Telephone 4167.

—— Under the direction of ——

SOUTHERN SPORTING PROMOTIONS LTD.

Managing Director :- Charles Knott

SPEEDWAY OFFICIALS

(LICENSED BY THE AUTO CYCLE UNION)

A.C.U Steward in Control	G. H. ALLEN
Clerk of the Course and Direction	CHARLES KNOTT
Judge & Announcer	H. W. RAWNSLEY-GURD
Timekeeper	H. A. MILLER
Chief Pit Marshall	STANLEY SELVES
Colour Marshall	T. DURHAM
Flag Steward	A. M. COOMBS
Medical Officer	Dr. V. D. PENNEFATHER

St. John Ambulance Brigade Section in attendance.

Speedway was reintroduced to Banister Court by Charlie Knott, and Southern Sporting Promotions Limited on Good Friday 10 April 1936. The match was a National Trophy clash against Cardiff which the Saints won 38-33, in front of a 14,000 crowd. The Saints met Cardiff four times in seven weeks, winning all four encounters, before Cardiff dropped out of the league.

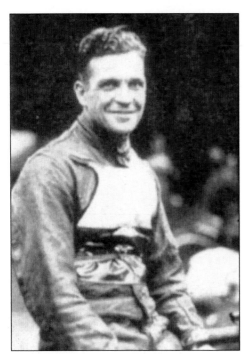
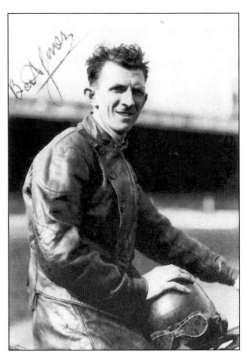

Left: Welshman Sid Griffiths joined Southampton from Harringay in 1936, and was a regular for four years, top-scoring in his first season for the Saints. *Right:* One of his team-mates in those four seasons was Australian Bert Jones, who had previously ridden for Plymouth. (*Southern Newspapers Limited*)

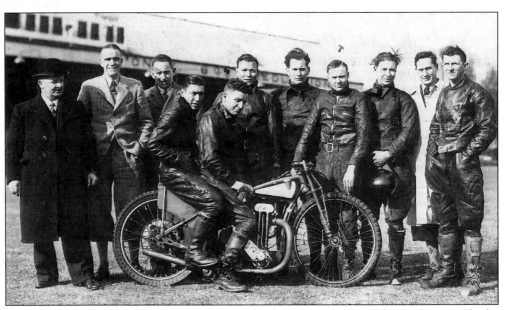

Southampton's Provincial League-winning team, 1936. From left to right, back row: Charlie Knott (promoter), Frank Goulden (captain), Arthur Westwood, Harry Lewis, Cyril Anderson, Alec Statham, Bob Evemy, Ivor Creek (mechanic), Bert Jones. On the machine: Bob Lovell, Sid Griffiths.

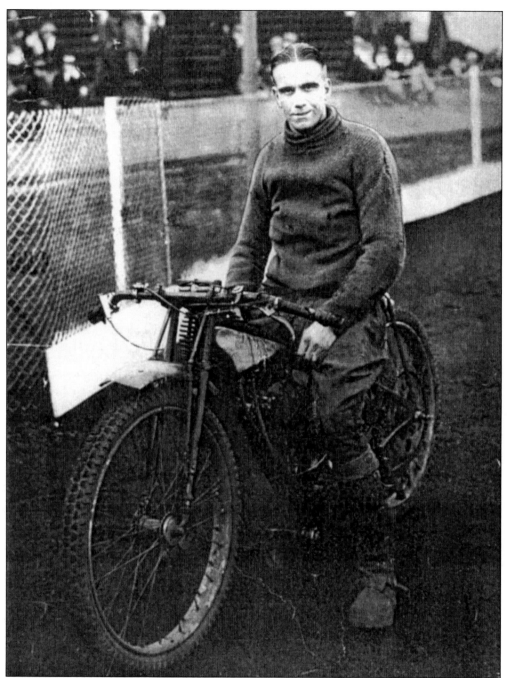

Saints star number three – Frank Goulden. Goulden was born in Southampton on 19 August 1909. He started riding at Banister Court in June 1929 and was a regular for the following three seasons. When the side moved to Lea Bridge, he went on to ride for West Ham and Plymouth, but returned to Banister Court on the resumption of speedway there in 1936. He captained the Saints and was virtually an ever-present until the war stopped proceedings. Goulden rode for the England Provincial League team against Australia in 1937, and was a reserve for the cancelled 1939 World Final. (*Hampshire Advertiser*)

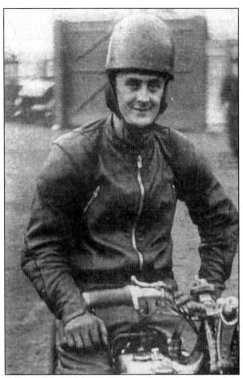

Billy Dallison was one of the pioneers of the sport, riding at the Birmingham tracks in 1928, and captaining the successful Hall Green side in 1930. However, lack of support meant that no speedway was to be seen there again until 1934, when Tom Bradbury Pratt reopened the track. Dallison again captained the side, but quickly moved on to Harringay, where he rode until joining Southampton in 1936, when he came third in the Provincial League Riders' Championship. He rode for the England Provincial League team against Australia in 1937 and was a strong scorer and a regular member of the Saints until the Second World War intervened. (*Stenner's*)

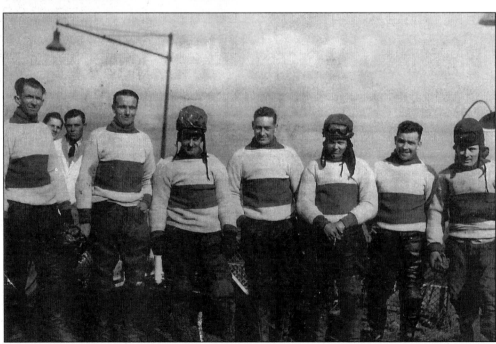

Southampton opened the 1937 season with a 38-32 win in a challenge match against First Division Harringay on 26 March. The Saints' team was, from left to right: Bert Jones, Frank Goulden (captain), Billy Dallison, Ivor Creek, Alec Statham, Sid Griffiths, Jack Riddle. Skipper Goulden top-scored with nine points.

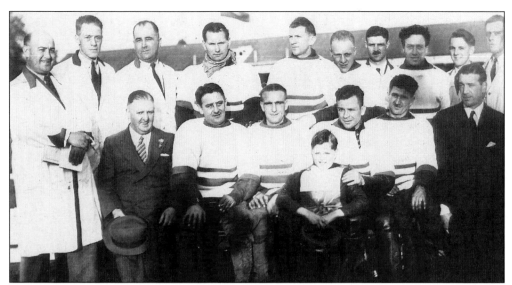

Southampton riders and officials, 1938. From left to right, back row: Stan Selves (pits marshal), Frank Bradley, Tom Durham, Cyril Anderson, Bert Jones, Jim Boyd, -?-, Jimmy Adams, Eric Selves, Alf Saunders. Front row: Charlie Knott (promoter), Billy Dallison, Frank Goulden (captain), Jim Knott (team mascot), Sid Griffiths, Ernie Rickman, Tom Bradbury Pratt (co-promoter).

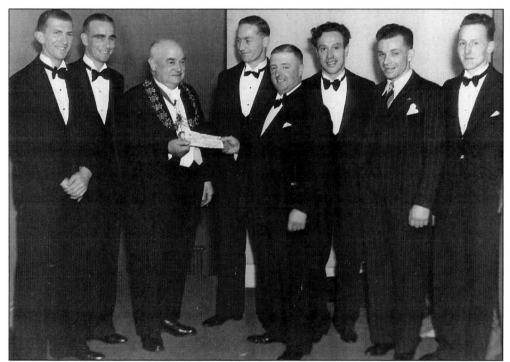

On Monday 18 October 1937, the mayor, Alderman Harry Chick, received a cheque for £500, raised by Southampton speedway supporters, in aid of the Shirley Children's Hospital. From left to right: Bert Jones, Frank Goulden, Alderman Harry Chick, Ivor Creek, Charlie Knott, Jimmy Adams, Sid Griffiths, Tommy Woods. (*Southern Newspapers Limited*)

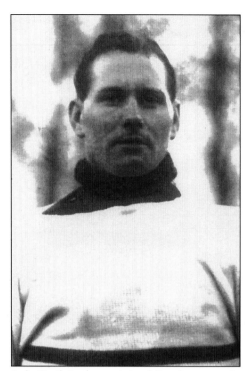 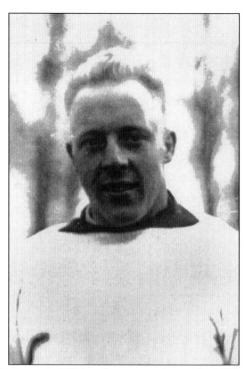

Left: Cyril Anderson joined Southampton from Harringay in 1936 and was a regular in the 1937 and 1938 seasons. *Right:* Maidenhead-born Jim Boyd had his first track experience at Rye House and Dagenham. Tom Bradbury Pratt signed him for Harringay in 1937, but he quickly moved on to the Saints during that season and continued to ride for them in 1938 and 1939.

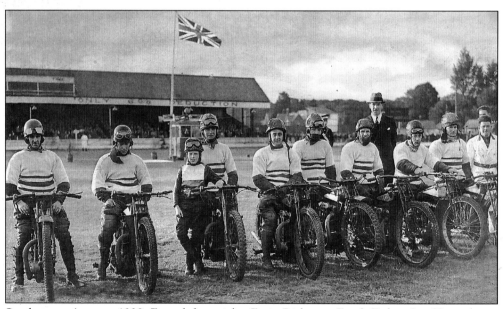

Southampton's team, 1938. From left to right: Ernie Rickman, Frank Dolan, Jim Knott (team mascot), Frank Goulden (captain), Billy Dallison, Sid Griffiths, Bert Jones, Tom Bradbury Pratt (standing), Jim Boyd, Cyril Anderson and George Beach (standing).

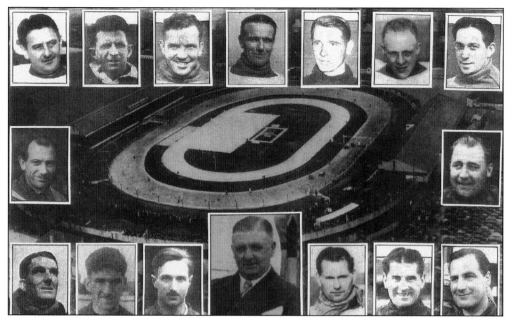

Southampton's team, 1939. Clockwise from the top: Billy Dallison, Bert Jones, Sid Griffiths, Frank Goulden (captain), Cordy Milne, Jim Boyd, Benny Kaufman, Gus Kuhn, E.D. Pye, Wally Kilmister, Cyril Anderson, Charlie Knott (promoter), Mike Erskine, Ernie Rickman, Alf Kaines, Danny Lee.

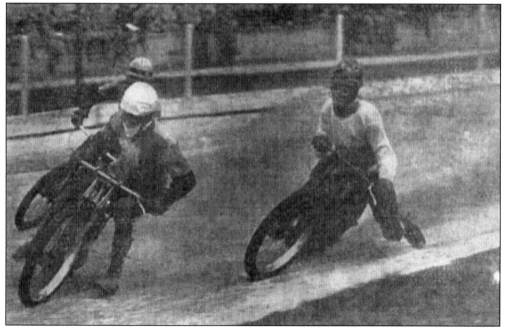

In the Saints' first meeting of the 1939 season on 7 April, they drew 42-42 in a challenge match with Harringay in front of a crowd of about 10,000. In heat one, Jack Parker led Frank Goulden for four laps, only for Goulden to snatch the win almost on the line with Billy Dallison in third place. Goulden went on to score a twelve points maximum. (*Southern Newspapers Limited*)

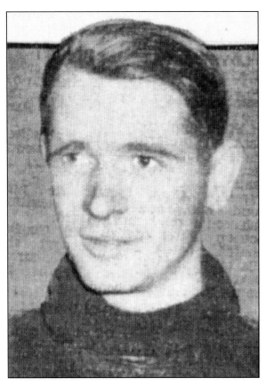

Born in Pasadena, Cordy Milne first came to England with his brother, Jack, and rode for Hackney Wick for two seasons, before captaining Bristol in 1938. He signed for the Saints in 1939 and was a prolific scorer, getting double figures twenty-seven times in thirty-one matches. He also won the South of England championship at Southampton. His record in the World Final was impressive, finishing fourth in 1936, third in 1937 and fifth in 1938. Milne finished top qualifier for the cancelled 1939 final and was clear favourite to win. Everyone has their favourite, but he is described by Jim Knott as arguably the best rider to have ridden for the Saints, combining individual brilliance with an ability to team ride. (*Southern Newspapers Limited*)

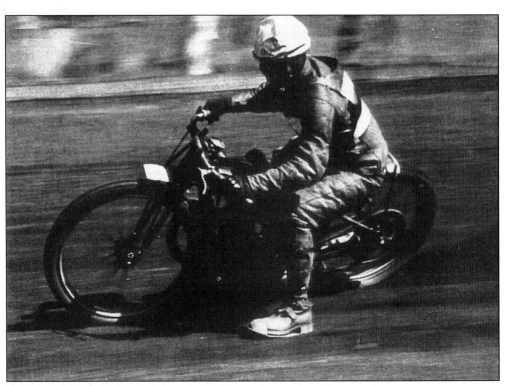

Cordy Milne illustrates his effortless 'armchair' style of riding. (*Stenner's*)

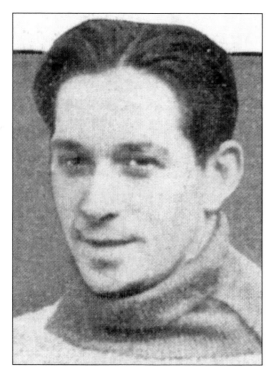

American Benny Kaufman, born in Manhattan in 1911, was just over five feet tall and barely ten stone in weight. He started off road racing in the States, before taking to the cinders and became very successful, winning the Eastern States Championship in 1936 and the National title in 1937. He came to England in 1938, joined Wimbledon and reached the World Final. Kaufman was allocated to Southampton in 1939. Despite missing several matches through a serious shoulder injury, he finished as the third highest scorer and again qualified for the World Final. (*Southern Newspapers Limited*)

Gus Kuhn was born on 17 October 1898, and was competing in motorcycle sport long before speedway came to England. After taking part in many of the early meetings in 1928, he captained Stamford Bridge to the first ever championship in 1929 and was very difficult to beat on the London track. Kuhn moved to Wimbledon in 1933 after the closure of Stamford Bridge and stayed with them for almost five years. He rode a few times for Wembley at the end of 1937, but the following year he had an excellent season captaining Lea Bridge in the Second Division. 'Old Father Gus', as he was popularly known, was signed by Southampton in 1939 to boost their strength at reserve, but four points in five matches was a disappointing return.

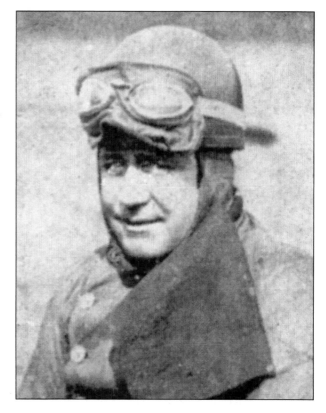

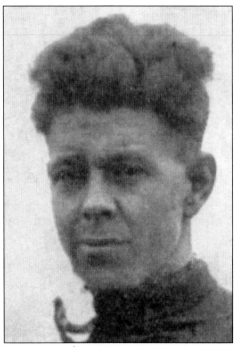
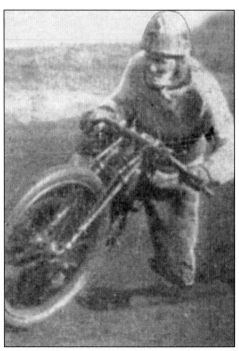

Harringay skipper Jack Parker, on the left, scored a fifteen points maximum to win the 'Sprouts' Elder Trophy at the Good Friday meeting in 1940. Saints' captain Frank Goulden (right) finished as runner-up with fourteen. They both also top scored for their teams in the challenge match on Easter Monday. (*Southern Newspapers Limited*)

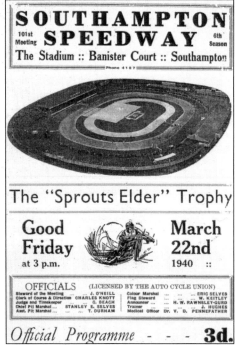
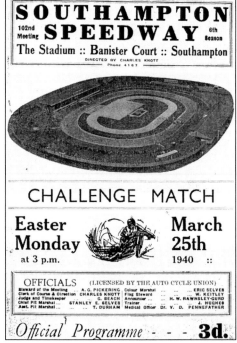

The programme covers for the only two meetings held at Banister Court Stadium in 1940.

Three

1947-1951

Southampton, 1947. From left to right: Frank Goulden (team manager), Peter Robinson, Alf Kaines, Bob Oakley, Bert Croucher, Vic Collins (captain, on machine), Jimmy Baxter (promoter), George Bason, Alf Boyce, Jim Squibb. (*Speedway World*)

The long-awaited first meeting after the war took place on Tuesday 29 April 1947. Because of bad weather, work on the track continued right up to the beginning of the meeting. Riders from Southampton and its sister track Plymouth competed for the 'Southampton Trophy'. It was won by the Saints' George Bason, with a fifteen points maximum. Peter Robinson was runner-up with fourteen. The race jacket of blue and red quarters, featured on the programme covers all season, was never worn by the Saints, whose colours were a red heart on a Cambridge blue background.

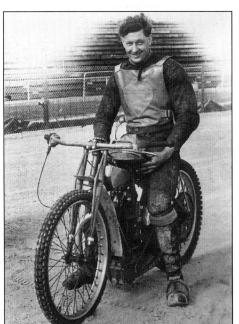 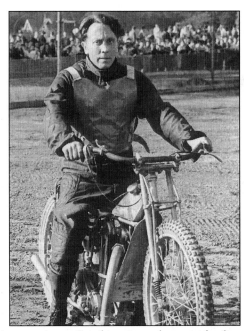

Left: Leg-trailer George Bason, who won the opening meeting at Southampton, also won the first meeting at Plymouth five days earlier. *Right:* Peter Robinson was runner-up at both meetings, and he and Bason skippered the Saints in 1947, when Vic Collins was missing through injury. (*E.G. Patience*)

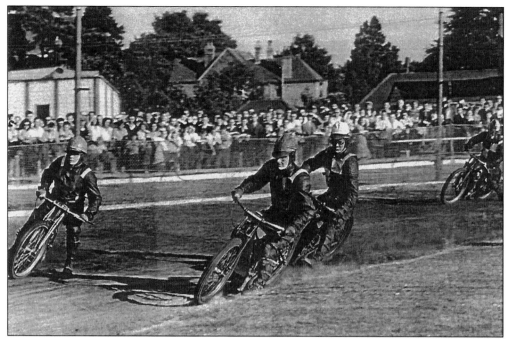

First-bend action in heat nine of the league match between Southampton and Wombwell on 3 June 1947. Peter Robinson and Alf Kaines lead Len Tupling and Ken Allick, and that is how the race finished, with Allick falling. The Saints won 57-27.

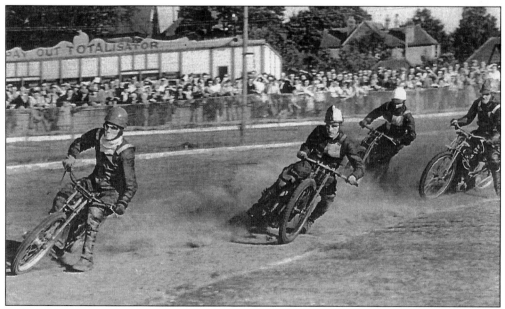

In heat ten of the league encounter between the Saints and the Colliers on 3 June 1947, Bob Oakley leads Bernard Thomas, Harwood Pike and Vic Collins, who later fell. Local man Oakley went on to record his first ever maximum for Southampton.

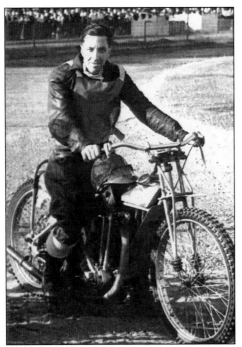

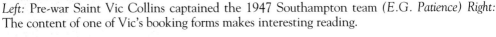

Left: Pre-war Saint Vic Collins captained the 1947 Southampton team *(E.G. Patience) Right:* The content of one of Vic's booking forms makes interesting reading.

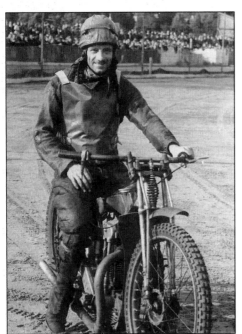
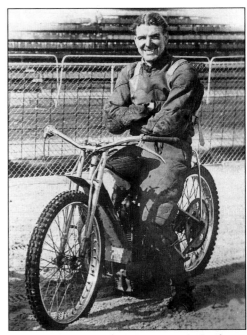

Left: Pete Lansdale was born in London in 1912 and joined Southampton in 1947 after a successful pre-war career on the grass and in TT racing. *(E.G. Patience) Right:* Another Londoner, Alf Kaines, rode for the Saints in 1938 and 1939, rejoining them in 1947 to add some experience to the team. *(E.G. Patience)*

50

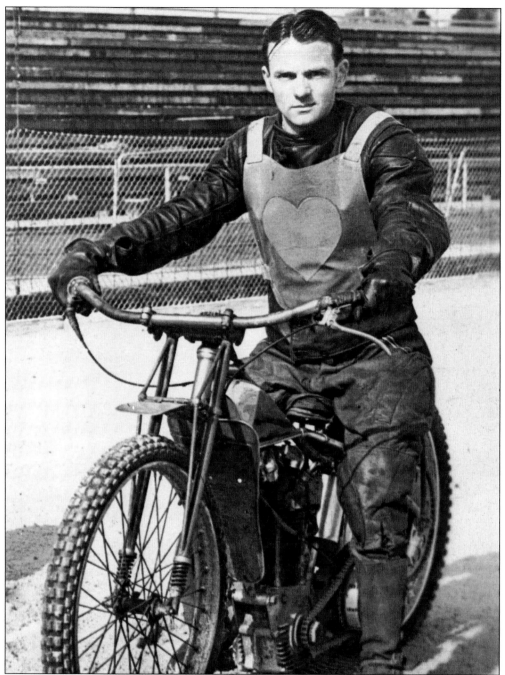

Saints star number four – Bob Oakley. Oakley was born in Southampton in 1922 and was an accomplished grass-track and scrambles rider. He had a few outings at New Cross in 1946, and was the subject of some controversy when the SCB made Southampton pay the London team £25 for his services. Oakley had a very successful three and a half seasons with the Saints, taking over the captaincy in 1949. Much to the dismay of the local fans, Wembley signed him in July 1950, and he went on to finish third in the 1952 World Final and become an English international. (E.G. Patience)

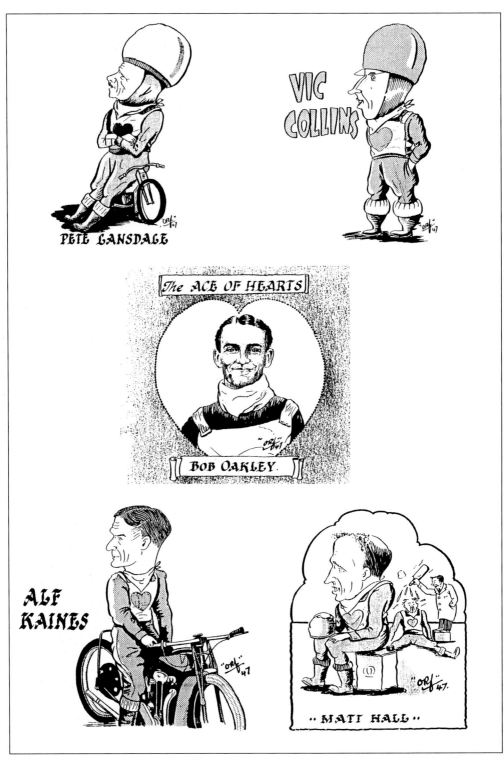

Opposite and above: Local artist 'Orf' puts pen to paper and draws the 1947 Southampton Speedway squad. (*Southampton programmes, 1947*)

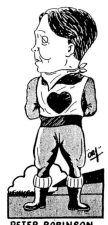

PETER ROBINSON

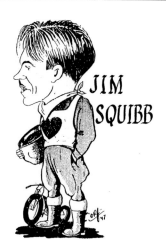

JIM SQUIBB

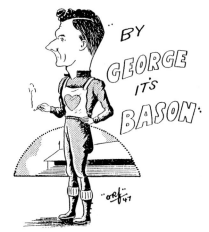

BY GEORGE IT'S BASON

BERT CROUCHER

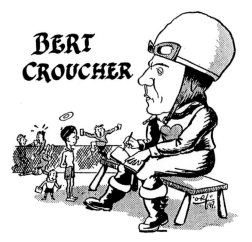

A SPECIAL PLACE IN OUR GALLERY FOR **TONY BUXEY** WHO GAINED TWO FIRSTS ON HIS FIRST LEAGUE APPEARANCE AGAINST CRADLEY HEATH

53

The first programme cover for the 1948 season featured the correct Southampton race jacket design of a red heart on Cambridge blue background. The match was a Division Three league clash with Exeter on Tuesday 6 April, which the Saints easily won 57-27. New skipper Alf Bottoms scored the first of his many maximums in Southampton's colours.

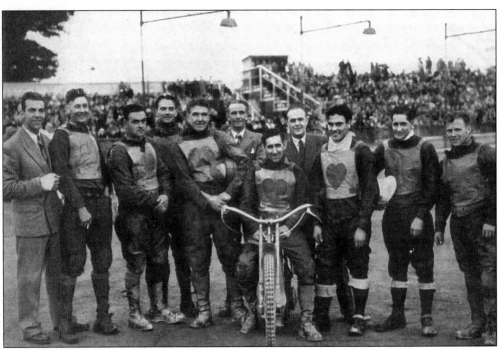

Southampton team, 1948. From left to right: Bert Croucher, George Bason, Tom Oakley, Bob Oakley, Alf Kaines, Frank Goulden (team manager), Alf Bottoms (captain, on machine). Jimmy Baxter (promoter), Jim Squibb, Cecil Bailey, Bill Griffiths. (*E.G. Patience*)

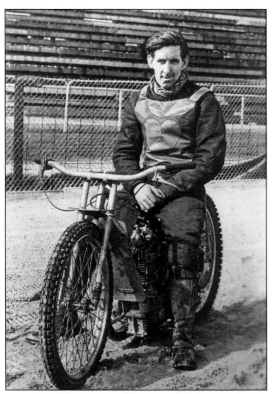

Alf Bottoms was born in Kensington, West London on 20 June 1908, and had his first experience of speedway at Rye House in 1945. He was signed by Wembley and was a member of the Lions' championship-winning team of 1946. Dogged with ill health throughout his career, he missed virtually all of the 1947 season. Bottoms came to Southampton in 1948, effectively in exchange for Peter Robinson. Appointed captain, he was a huge success, scoring twenty-four maximums, and he was almost unbeatable on Third Division tracks. He returned to Wembley for the 1949 season to avoid the greater travelling there would have been in Division Two with the newly-promoted Saints team. (E.G. *Patience*)

Alf Bottoms practising at Banister Court before the start of the 1948 season. (E.G. *Patience*)

Saints star number five – Jim Squibb. Squibb was born in Poole in 1920 and after success on the local grass tracks, he was invited to ride in the first meeting after the war at Banister Court. He did very well, scoring ten points. He became a tower of strength in the Saints side, taking over the captaincy in 1950, and was an ever-present right through to the closure in June 1951. Squibb returned to Banister Court in 1957, where he had a very successful two and a half seasons, winning an England cap in 1958. He is Southampton's top league points scorer and he also made the most league appearances. (*E.G. Patience*)

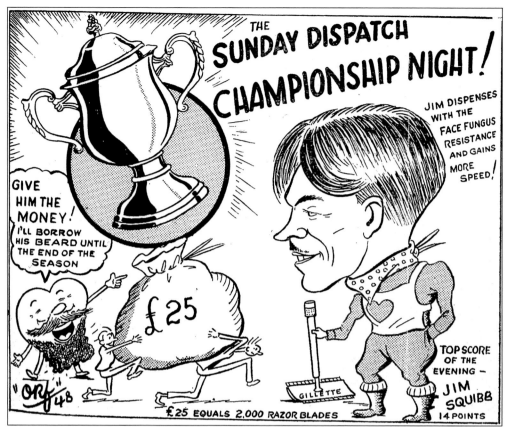

Jim Squibb said he would shave off his beard after he had won his first race of the season. 'Orf', in his drawing, is suggesting this has given him more speed, resulting in him winning the Southampton round of the *Sunday Dispatch* Speedway Riders Championship. (*Southampton programme, 11 May 1948*)

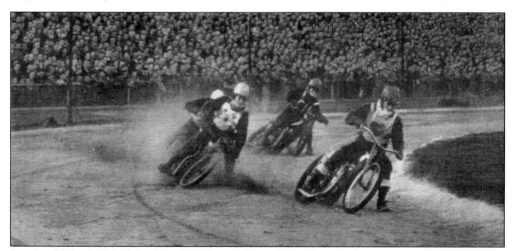

Jim Squibb leads Gil Blake (Hanley), Eric Salmon (Bristol) and Alan Hunt (Cradley Heath) in heat one of the championship on Tuesday 20 April 1948. Squibb won the meeting with a score of fourteen points, losing only to team-mate Alf Bottoms. (*E.G. Patience*)

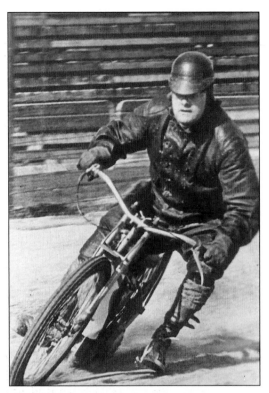

Tom Oakley practising at Banister Court before his first season of speedway racing in 1948. Like his younger brother, Bob, he was a star of the grass tracks and a member of Southampton and District Motor Cycle Club. Starting as a reserve, he scored 209 points in his initial season and his rumbustious style made him a big favourite with the Southampton supporters. (*E.G. Patience*)

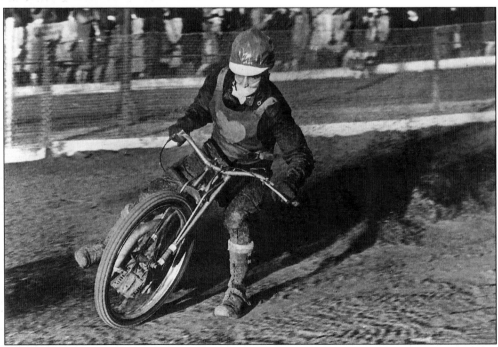

Cecil Bailey, another newcomer to the Saints' team in 1948, shows his neat style at Banister Court. His rise from reserve to heat leader in a few short months was very impressive and he was a tremendous acquisition to the side. (*E.G. Patience*)

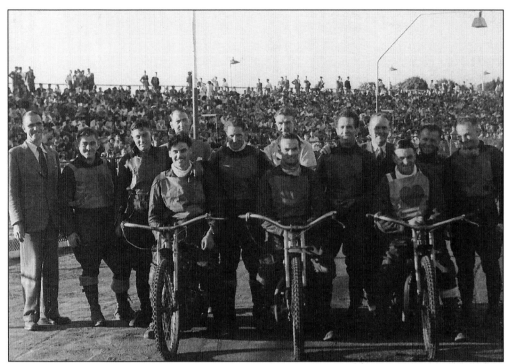

Southampton team, 1949. From left to right, back row: Frank Goulden (team manager), Bill Thatcher, Phil Bishop, Peter Bantock (director), Cecil Bailey, Alf Kaines, Bill Rogers, Jimmy Baxter (promoter), Bill Griffiths, Roy Craighead. Front row, on machines: Jim Squibb, Bob Oakley (captain), Tom Oakley. (*E.G. Patience*)

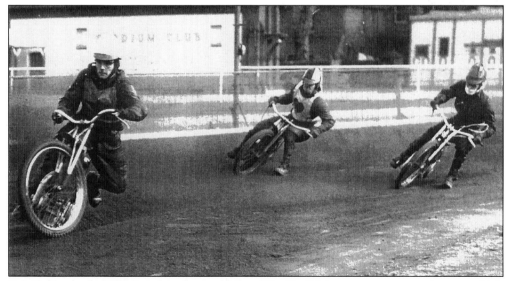

Bob Oakley leads Alf Kaines (on the outside) and Jim Squibb in a pre-season practice race which skipper Oakley won in 68.2 seconds. (*E.G. Patience*)

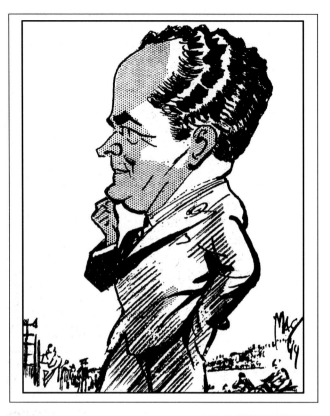

Jimmy Baxter was the promoter at three tracks in 1928. He put on dirt-track racing at Celtic Park, Glasgow, Custom House, West Ham, and Banister Court, Southampton. In 1949, his company, Southern Speedways Limited, controlled three tracks – at Southampton, Pennycross Stadium, Plymouth, and Stanley Stadium, Liverpool. (*Stenner's*)

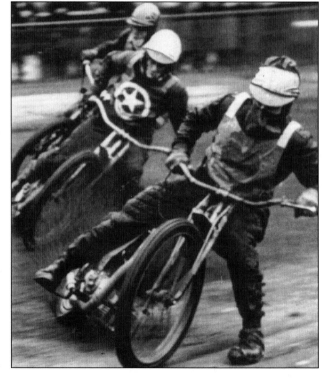

Former Wembley Lion Roy Craighead was born in Eltham in 1916 and started his speedway career at Rye House. He made occasional appearances for Wembley in 1946, and became a regular in the 1947 and 1948 seasons. He signed for Southampton in 1949 when Alf Bottoms returned to the Lions and, after a slow start, he became a solid scorer, developing a very powerful partnership with Jim Squibb. (*E.G. Patience*)

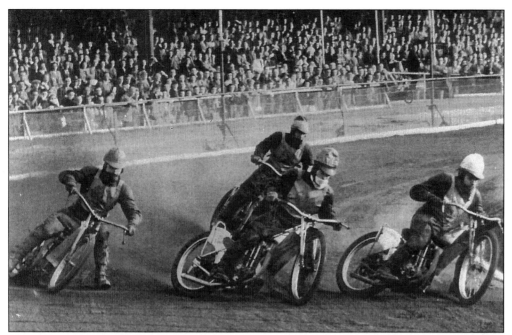

Heat two action in the league match between the Saints and the Bulldogs at Banister Court on 14 June 1949. From left to right: Alf Kaines (Southampton), Roger Wise (Bristol), Jim Squibb (Southampton), Eric Salmon (Bristol). Squibb eventually cut inside Salmon to win in 68.4 seconds, with Wise beating Kaines for third place for a 3-3 shared heat. (*E.G. Patience*)

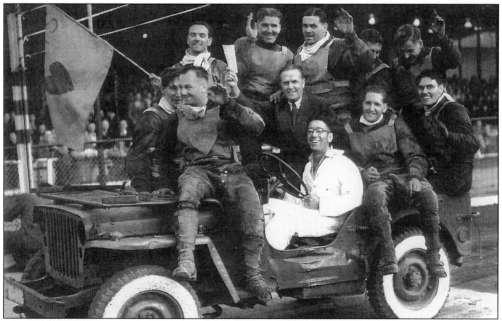

The Southampton team which defeated Bristol 45-39 at Banister Court on 14 June 1949. From left to right, back row: Bob Oakley (captain), Alf Kaines, Tom Oakley, Phil Bishop, Bill Thatcher. Front row: Mike Beddoe (Bristol), Roy Craighead, Jimmy Baxter (promoter), Cecil Bailey, Jim Squibb. (*E.G. Patience*)

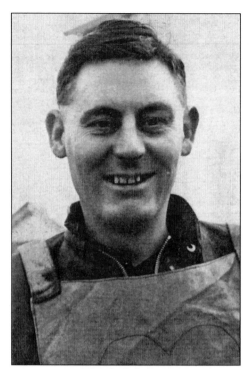
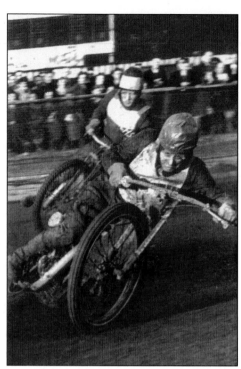

Pre-war Saint Phil Bishop returned to Banister Court in 1949 for a couple of seasons, and thrilled the crowds with his spectacular leg-trailing style. *(Monthly Speedway World and E.G. Patience)*

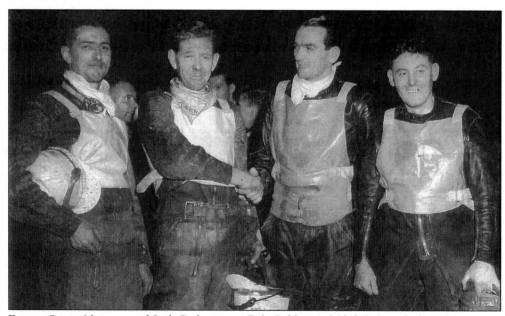

Former Saints Norman and Jack Parker greet Bob Oakley and Phil Bishop, before the pre-war versus post-war challenge match on 11 October 1949. Bishop was a team-mate of the Parkers in the Saints' 1932 line-up. *(E.G. Patience)*

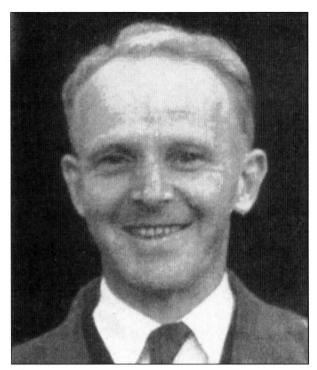

Arthur Charles Palmer, or 'Orf', as he was known to the Saints fans, began contributing drawings to Southampton speedway programmes and brochures in 1929, and his first serious effort was a cartoon of Jimmy Hayes. Southampton-born, he also supplied and wrote the words for his work. His ability to represent accurately significant events concerning Southampton Speedway made him very popular. The fans would often look for the pages of his cartoons before reading the rest of the programme.

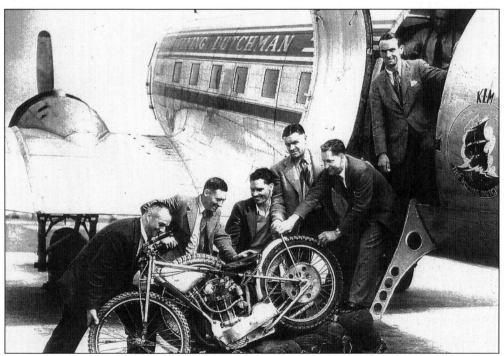

Southampton speedway team, together with Midlands track Tamworth, acted as ambassadors for the sport in 1949, when they flew to Milan and rode in a series of exhibition matches against each other. Loading a bike onto *The Flying Dutchman* are, from left to right: Roy Craighead, Phil Bishop, Jim Squibb, Tom Oakley, Cecil Bailey, Bob Oakley.

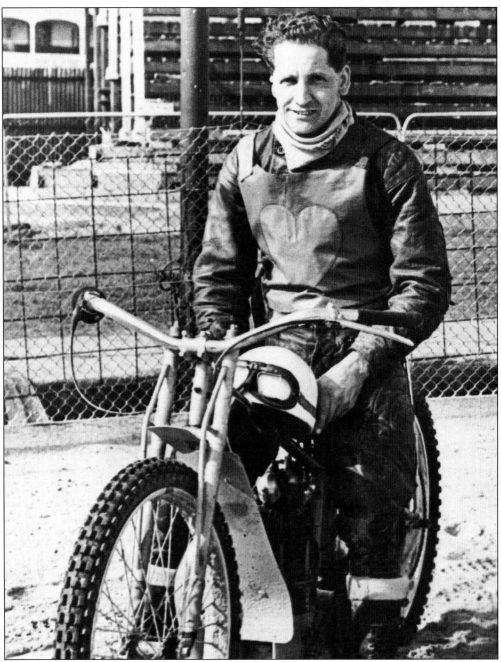

Saints star number six – Cecil Bailey. Bailey was born in Liverpool on 29 June 1918 and moved to Southampton at the tender age of three. He was a member of the Southampton and District Motor Cycle Club and became a brilliant all-round motorcyclist, before joining the Saints in 1948. His progress was meteoric, and he scored 322 league points in his first league season and was awarded the *Speedway World* trophy for the most outstanding newcomer. Bailey had another excellent season at the higher level of Division Two in 1949 but, much to the disappointment of the fans, he moved to Plymouth in 1950. However, he returned to Banister Court later that season. He only rode a few times in 1951 and retired when the track closed. (*E.G. Patience*)

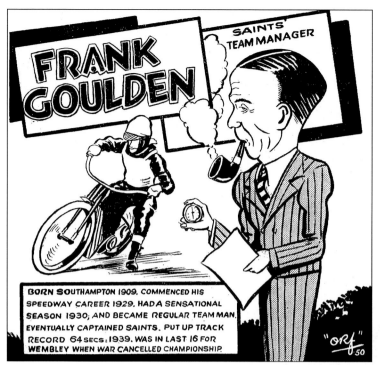

BORN SOUTHAMPTON 1909, COMMENCED HIS SPEEDWAY CAREER 1929. HAD A SENSATIONAL SEASON 1930; AND BECAME REGULAR TEAM MAN. EVENTUALLY CAPTAINED SAINTS. PUT UP TRACK RECORD 64 SECS: 1939. WAS IN LAST 16 FOR WEMBLEY WHEN WAR CANCELLED CHAMPIONSHIP.

Unable to ride for the Saints in 1947 because of the ruling that pre-war First Division star riders could not ride in Division Three, Frank Goulden became team manager. He worked very hard to rebuild the Southampton side, mainly from grass-track specialists. His efforts were rewarded by two third placings in 1947 and 1948 and promotion to the Second Division in 1949. (*Southampton programme, 29 August 1950*)

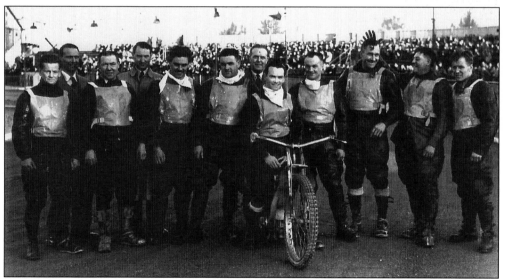

Southampton team, 1950. From left to right: Buck Whitby, Frank Goulden (team manager), Les Wotton, Peter Bantock (director), Jim Squibb, Tom Oakley, Jimmy Baxter (promoter), Bob Oakley (captain, on machine), Roy Craighead, Steve Langton, Phil Bishop, Bill Griffiths. (*Southern Newspapers Limited*)

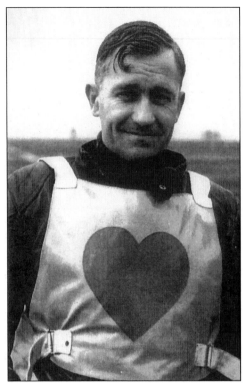

Left: Australian Steve Langton, a pre-war Saint of 1931 and 1932, rejoined Southampton in 1950. He was the all-time top scorer for Tamworth and, although at the veteran stage, was a useful addition to the team. *Right:* Former England international and World Finalist Les Wotton, a man of many clubs, also joined the Saints in 1950 for a couple of seasons. Although well past his brilliant best, he had the occasional high-scoring meeting. (*E.G. Patience*)

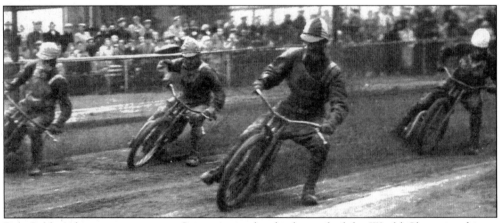

Bob Oakley's last appearance as a Saint was in the third round of the World Championship at Banister Court on 25 July 1950. He is leading in heat five, from left to right: Ron Mason (Belle Vue), Hugh Geddes (Swindon), Ken Adams (Hanley). Oakley went on to win in 68.2 seconds, but lost the £40 winner's cheque when he blew a valve when leading by a quarter of a lap in his fourth ride. However, Wembley manager Duncan King was in the crowd and must have been impressed as he happily paid £1,500 for Oakley's transfer to the Lions. (*E.G. Patience*)

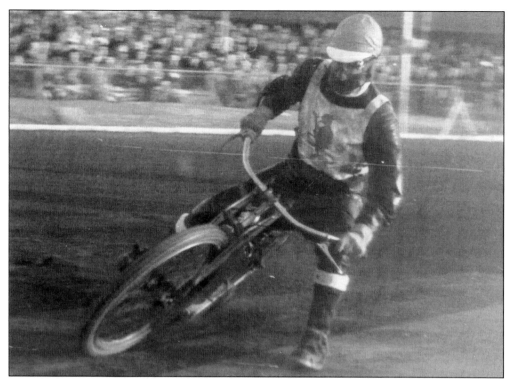

Cecil Bailey, riding for the Plymouth Devils at Pennycross Stadium before returning to Southampton in August 1950.

The Southampton team which lost their last league match of the 1950 season 49-34 at Walthamstow on 16 October. From left to right, back row: Alf Squibb (team mascot), Steve Langton, Les Wotton, Cecil Bailey, Buck Whitby, Jimmy Baxter (promoter). Front row: Bill Holden, Harold McNaughton, Tom Oakley, Jim Squibb (captain). (*Speedway News*)

Bad weather and the crippling entertainment tax made life very difficult for the Southampton Speedway management in 1950 and 1951, as indicated in this 'Orf' drawing. (*Southampton programme, 6 April 1951*)

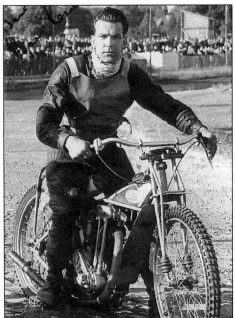

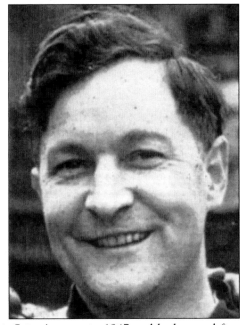

Left: Southampton-born Bert Croucher started his Saints' career in 1947 and had a good first season, but 1948 was marred by injury. He went on loan to skipper the new Third Division team Oxford in 1949, but did not appear in 1950, despite continuing to ride on the grass. He came out of retirement to rejoin Southampton in 1951. (E.G. Patience.) *Right*: Fast-gating Charlie May was born in Southampton in 1917 and made four appearances for the Saints in 1938. After the war, he rode for Wembley, Birmingham and Walthamstow, before rejoining his home town club for the short-lived 1951 season. After spells at Cardiff and Exeter, he came back to Banister Court in 1954, where he stayed until he retired two years later. (*E.G. Patience*)

The programme cover for the last home league meeting on Tuesday 12 June 1951, when Southampton beat Hanley 57-27, after which Jimmy Baxter withdrew the team from the league. Crowds were poor, entertainment tax had to be paid, and despite staff taking wage cuts and Charlie Knott halving the stadium rent, the management could not sustain the losses it was making. The riders would not accept a pay cut so Jimmy Baxter had no choice but to close. Thanks to the determination and efforts of Charlie Knott, however, it was only for a few months before Southampton Speedway was up and running again in 1952.

Southampton team, 1951. From left to right, back row: Charlie May, Les Wotton, Jimmy Baxter (promoter), Bert Croucher, Tom Oakley. Front row: Roy Craighead, Harold McNaughton, Bill Holden, Jim Squibb (captain).

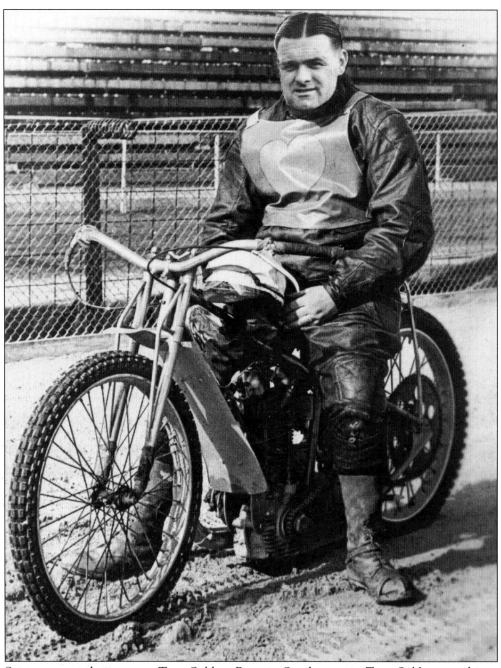

Saints star number seven – Tom Oakley. Born in Southampton, Tom Oakley was thirty-seven when he made his debut for the Saints in 1948. Starting as a reserve, he made steady progress, getting over two hundred points. The Southampton fans liked him because of his determination and never-say-die attitude. He took promotion to Division Two in his stride and by 1950 was a forceful heat leader. He finished as top league points scorer in 1951 and won the World Championship round at Banister Court on 10 July with a fifteen points maximum. After the closure, he rode for New Cross and Bristol before retiring at the end of the 1954 season. (*E.G. Patience*)

Four

1952-1956

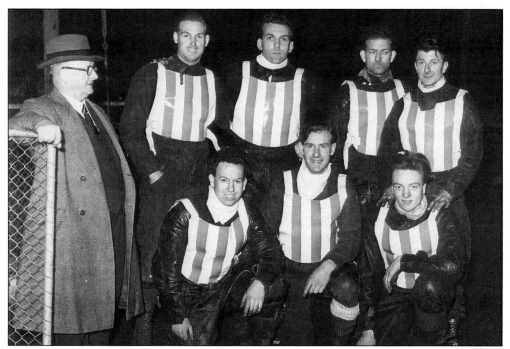

The Southampton team which beat Long Eaton 57-27 in the first match of the 1952 season on 11 April, in front of a crowd of nearly 8,000. From left to right, back row: Charlie Knott (promoter), Ted Moore, Bert Croucher (captain), Mike Tams, Colin Clarke. Front row: Roy Bartlett, Maury Mattingly, Dudley Smith. (*Southern Newspapers Limited*)

Some of the ambitious riders who took part in the speedway trials at Banister Court Stadium before the start of the 1952 season. Eventual team members Dennis Cross, Jack Vallis, Bert Croucher, Dudley Smith and Maury Mattingly can be seen, together with Southampton promoter Charlie Knott. (*Southampton Newspapers Limited*)

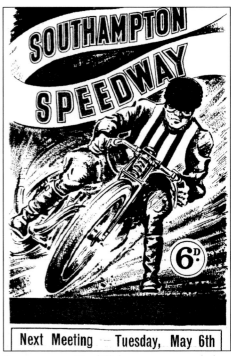

Left: When the Saints closed in 1951, Bert Croucher went to Cardiff, but was persuaded to rejoin the team as captain in 1952. He worked very hard on and off the track to help Charlie Knott build the new Southampton side and set a fine example by scoring over two hundred league points. (*Speedway World*) *Right:* The first two programmes still showed the old team colours and it was not until this third home meeting on 29 April that the cover showed a rider in the new red and white striped jacket.

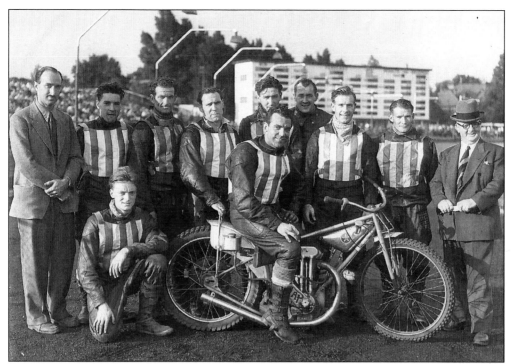

Southampton riders line up before their 45-39 home defeat by Exeter on 1 July 1952. From left to right: Mike Erskine (team manager), Dennis Cross, Dudley Smith (kneeling), Mike Tams, Dennis Hayles, Bert Croucher (captain, on machine), Jack Vallis, Aston Quinn, Maury Mattingly, Brian McKeown, Charlie Knott (promoter). (*Southern Newspapers Limited*)

First-bend action in heat one of the Saints-Falcons Southern League match on 1 July 1952. Southampton's Dudley Smith hugs the white line ahead of Exeter's Jack Geran, while Bert Croucher powers around the outside of Neil Street. Croucher won in 67.6 seconds from Smith, Street and Geran to give the Saints a 5-1 win. (*Southern Newspapers Limited*)

A drawing by 'Orf' of the situation in 1951 when Southampton Speedway closed down. Charlie Knott offered his help and after a bleak winter the Saints were in action again. It took time to build a team from scratch and early results were disappointing, but by the end of the season the Saints had beaten champions Rayleigh and third-placed Plymouth twice. The foundations had been laid in 1952 and with Charlie Knott in charge, the future for Banister Court supporters looked much brighter. (*Southampton Speedway Souvenir Brochure, 1952*)

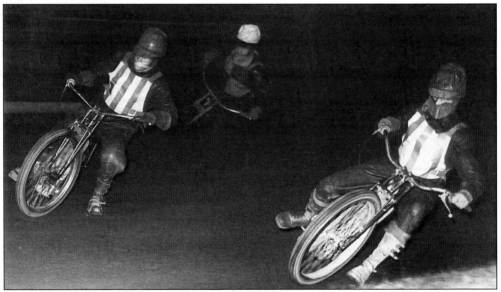

Heat one of Southampton's big 60-24 win over Aldershot at Banister Court on 23 September 1952. Dudley Smith, on the inside, is pictured here heading for a new track record of 64.4 seconds. Team-mate Brian McKeown is on the outside, with Aldershot's Bill Grimes in third place. (*Southern Newspapers Limited*)

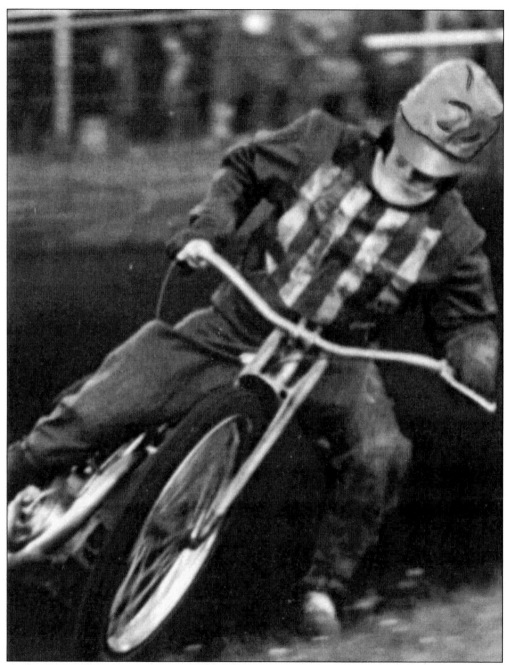

Saints star number eight – Brian McKeown. New Zealander McKeown was born on 12 June
1927. After being set up with excellent equipment by Mike Erskine, McKeown made his Saints
debut on 27 May 1952, finishing top scorer in his first season. He also won individual meetings
and made several representative appearances in 1952 and 1953. He missed the beginning of the
1954 season recovering from a broken leg. McKeown was a notoriously slow gater and thrilled
the fans by winning most of his races from the back. After a few years at home, he did well at
Middlesbrough in the Provincial League, and rode a couple of times for the Saints in 1963, before
again breaking his leg. (*Southern Newspapers Limited*)

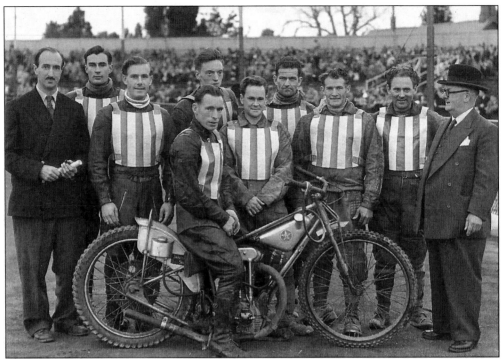

Southampton team, 1953. From left to right: Mike Erskine (team manager), Brian Hanham, Maury Mattingly, Ernie Rawlins (captain, on machine), Dudley Smith, Ernie Brecknell, Mike Tams, Brian McKeown, Hugh Geddes, Charlie Knott (promoter). *(Southern Newspapers Limited)*

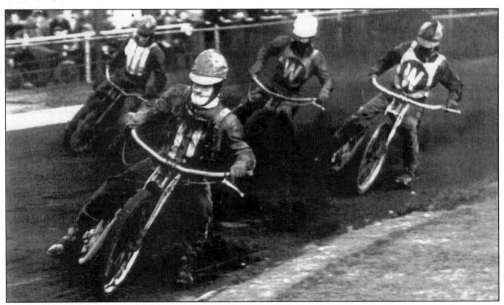

Southampton's Maury Mattingly leads at the first bend at Banister Court on 12 May 1953, followed by, from left to right: Vic Gooden (Southampton), Harry Bastable, Derek Braithwaite (Wolverhampton). Mattingly won the heat and scored a brilliant fourteen points in this National Trophy clash which the Wolves won 59-49. *(Southern Newspapers Limited)*

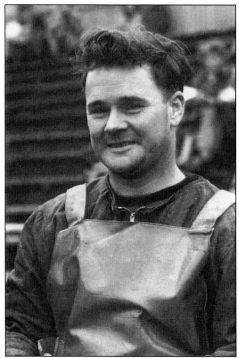

Born in Sydney, Australia, diminutive Ernie Brecknell first came to England in 1948 to ride for West Ham, breaking his leg in his second meeting. Moving to Newcastle in 1949, he broke his leg again in 1951. Southampton signed him in July 1952 and after an unspectacular start he finished the season well. He appeared again for the Saints in 1953 and 1954 and his bustling style made him exciting to watch and popular with the local supporters. (*Southern Newspapers Limited*)

Three young Southampton hopefuls in the 1953 season, Brian Hanham, Jack Vallis and Harold George, enjoying a break between races while mechanic Frank Hedgecott works on the bikes.(*Speedway Star*)

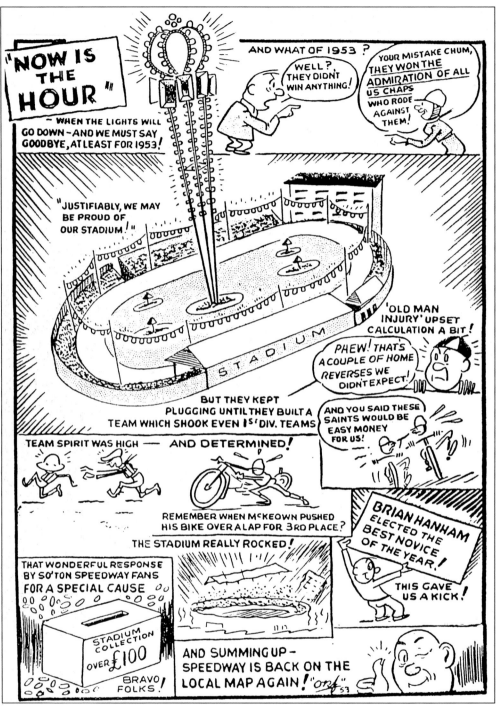

The drawing by 'Orf' at the end of 1953 sums up what was a satisfactory season in the revival of Southampton Speedway.

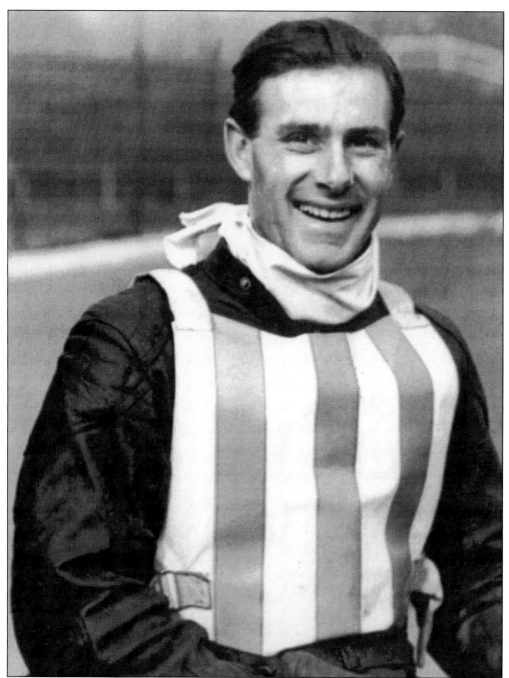

Saints star number nine – Maury Mattingly. Mattingly was born in Totton on 22 October 1923 and made his league debut for the Saints on 11 April 1952. He served the Saints well, riding in the red and white stripes for six seasons, before going to Coventry in 1958. He also rode for Plymouth, Wolverhampton and Glasgow. Mattingly came third in the 1961 Provincial League Riders Championship and was the first Englishman to win the Scottish Open Championship in 1963. His fast-gating, smooth riding style was attractive to watch and he combined his racing with a very successful frame-making business. (*Southern Newspapers Limited*)

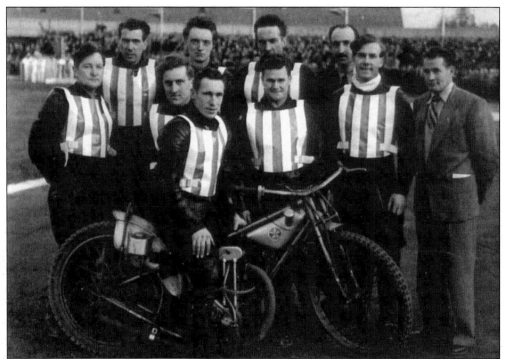

Southampton team, 1954. From left to right, back row: Ken Adams, Dudley Smith, John Fitzpatrick, Mike Erskine (team manager). Front row: Charlie May, Gerald Pugh, Ernie Rawlins (captain, on machine), Ernie Brecknell, Maury Mattingly, Brian McKeown.

Promoter Charlie Knott welcomes captain Ernie Rawlins to the 1954 season with his team mates, from left to right: Mike Erskine (team manager), Dudley Smith, John Fitzpatrick, Brian Hanham, Ken Adams, Jim Gleed, Maury Mattingly, Harold George, Charlie May. (*Southern Newspapers Limited*)

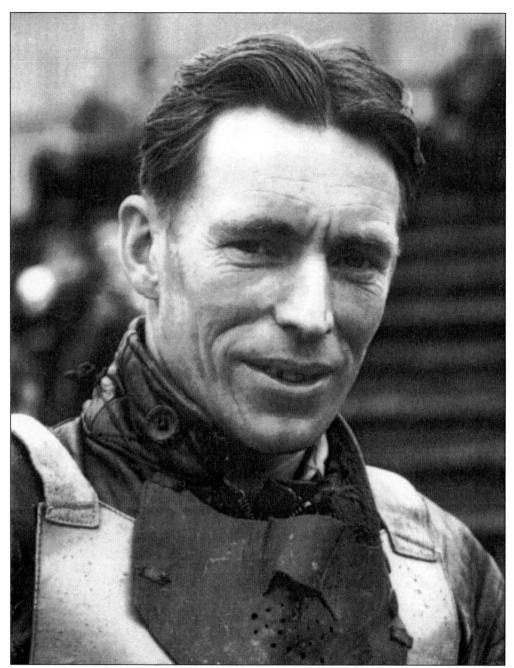

Saints star number ten – Ernie Rawlins. Born in Southampton in 1922, Rawlins made his debut for the Saints on 23 September 1947 in a Knock Out Cup match against Exeter. He had another three outings in 1948, and the following year moved to Oxford, where he had considerable success. Rawlins returned to Banister Court in 1953, taking over the captaincy, and was one of Southampton's leading scorers for four seasons. Tragedy struck at the last home meeting of 1956, on 18 September, when he crashed in his first ride, suffering head injuries from which he died four days later. A loyal team-man and a popular captain, he was greatly missed at Banister Court. (*Southern Newspapers Limited*)

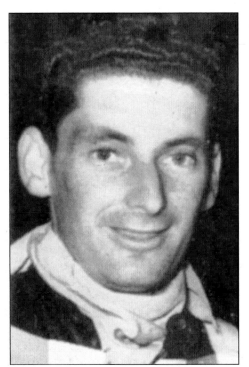 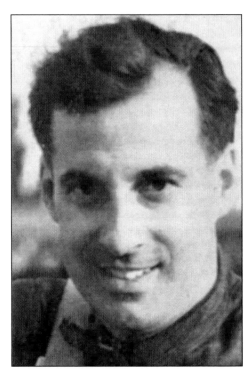

Left: Australian Allan Quinn was signed from Harringay in 1955, but unfortunately missed a lot of matches through injury. *Right:* England international Dick Bradley joined the Saints after Bristol closed in June 1955 and scored double figures in nineteen of his twenty-three matches that season.

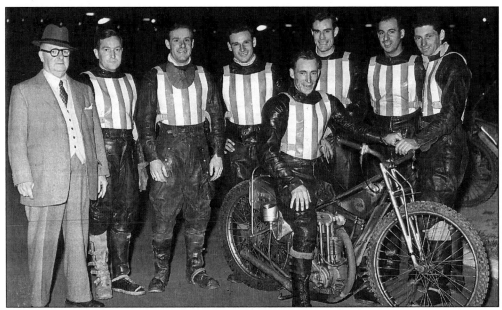

Southampton team, 1955. From left to right: Charlie Knott (promoter), Charlie May, Maury Mattingly, Alby Golden, Ernie Rawlins (captain, on machine), Brian Hanham, Dick Bradley, Allan Quinn.

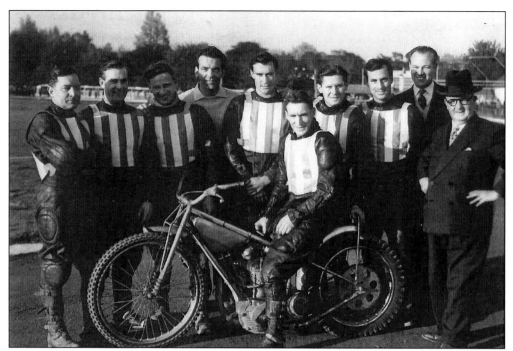

Southampton team, 1956. From left to right: Charlie May, Maury Mattingly, Alby Golden, Bert Croucher (team manager), Brian Hanham, Ernie Rawlins (captain, on machine), Johnny Hole, Dick Bradley, Tom Misselbrook (machine examiner), Charlie Knott (promoter). *(Southern Newspapers Limited)*

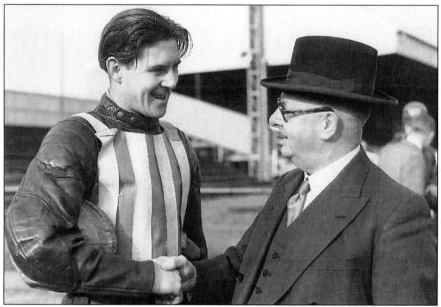

Saints' promoter Charlie Knott welcomes new 1956 signing Johnny Hole to Banister Court. Hole was a member of the Bristol Bulldogs for eight seasons until they closed in 1955. His all-action style made him very popular with the Southampton supporters and he was a regular at Banister Court for nearly five years. *(Southern Newspapers Limited)*

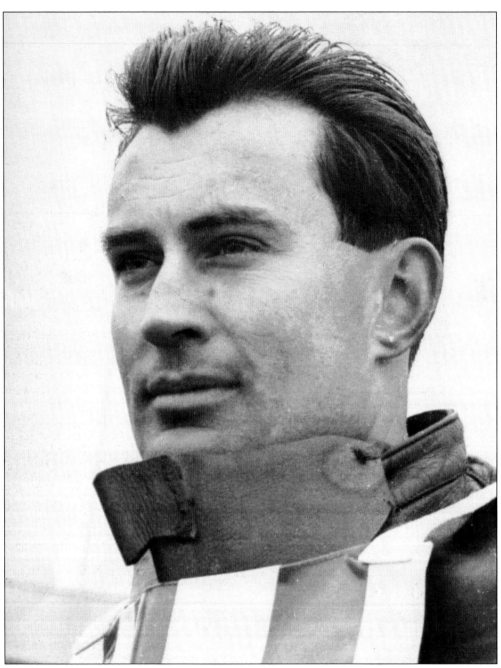

Saints star number eleven – Brian Hanham. Although born in Southampton on 20 April 1932, Hanham lived his early years in Ferndown and was a team-mate of Brian Crutcher in the Newtown Eagles cycle speedway side. He learned the rudiments of speedway at Matchams Park and signed for the Saints at the end of 1952, making his debut at reserve on 3 October. In 1953, he was nominated 'The Speedway World Novice of the Year'. Hanham then developed into a top-class rider, his daring, tearaway style making him a great favourite with fans all over the country. He appeared for the Saints in ten seasons and is the sixth all-time highest scorer. (A.C. Weedon)

A feature of the 1956 season was the number of second-half trophies won by Dick Bradley. Watched by Charlie Knott, Dick is presented with yet another one by Mrs Clark, a supporter since 1930.

Lining up behind Charlie Knott are 1956 riders, from left to right: Ernie Rawlins (captain), Johnny Hole, Bert Croucher (team manager), Brian Hanham, Alby Golden, Frank Bettis, Ron Sharp, Maury Mattingly, Dick Bradley, Frank Hedgecott (mechanic). *(Leonard Birch)*

SOUTHAMPTON STADIUM MOTOR CYCLE RACING
Tuesday, October 9th, 1956 at 7.30 p.m.

Ernie Rawlins Memorial Meeting
for the Speedway Supporters' Challenge Cup

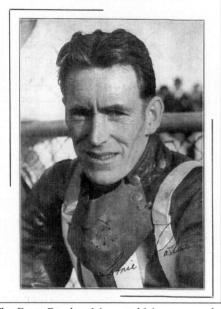

A TRIBUTE
(by "Nomad")

It is hard to believe that we shall never see Ernie Rawlins riding the Stadium track again.

Hard to believe because all who followed the "Saints" had come to regard their popular skipper as part and parcel of the local speedway scene, a regular who never let his team down and never disappointed the fans.

Week in, week out, he was always there, a great favourite with the crowd, smilingly acknowledging their cheers as he led the parade before racing, and then when the real business began, riding with characteristic dash and skill, setting a grand example to his colleagues.

His was a remarkable record. From the day he was appointed skipper of the "Saints" in April, 1953, when Bert Croucher retired, until his fatal crash only three weeks ago, he never missed a match.

In the 1953 season he rode in 42 matches, scored 351 points; in 1954 in 48 and scored 269 points; in 1955 in 43 and scored 404 points; and this last season in 37, which brought him 381 points. A total of 160 matches and 1,405 points—a record any rider can be proud of.

No one was happier than Ernie that his team did so well this summer, even though sheer bad luck robbed them of the Division II championship they so richly deserved.

A sportsman to his finger-tips, a loyal friend and colleague, he epitomised the fine team spirit which enabled the "Saints" to go through last season unbeaten at home.

It would have warmed his heart to see the way his team-mates rode to preserve that proud record after he had been injured on September 18th.

"I am proud and privileged to have skippered such a grand bunch of chaps," he wrote in that final programme.

They, too, I know, are proud and privileged that they rode with such a grand captain, a man who loved this tough, exacting sport and upheld its highest traditions.

Speedway is the poorer for his passing.

The Ernie Rawlins Memorial Meeting was held on 9 October 1956 and the programme included a tribute from local speedway reporter 'Nomad'.

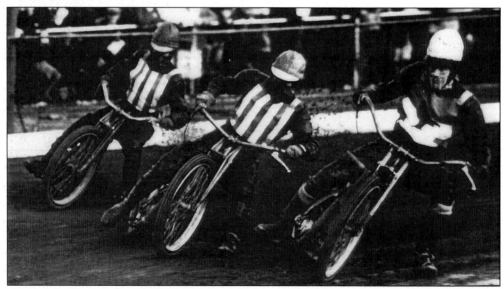

First-bend action in the 57-39 league win over Swindon at Banister Court on 7 August 1956. From left to right: Bill Holden and Ernie Rawlins (Southampton), and on the inside is Ian Williams (Swindon). Ernie Rawlins scored twelve points from five rides.

Five

1957-1960

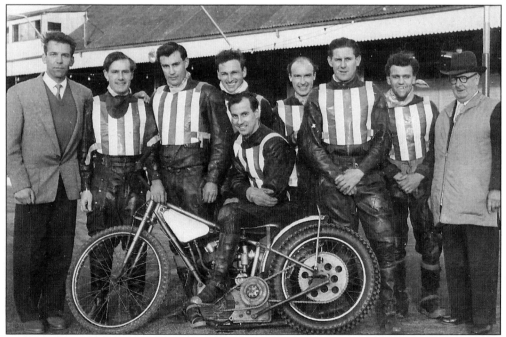

Southampton team, 1957. From left to right: Bert Croucher (team manager), Maury Mattingly, Brian Hanham, Alby Golden, Dick Bradley (captain, on machine), Bill Holden, Johnny Hole, Brian Crutcher, Charlie Knott (promoter). *(A.C. Weedon)*

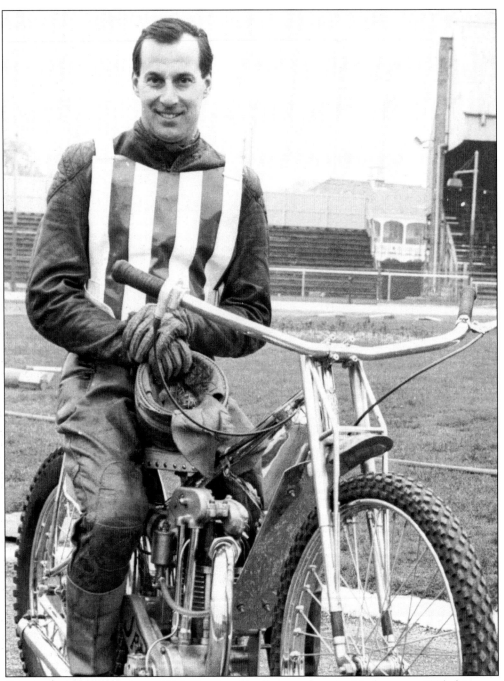

Saints star number twelve – Dick Bradley. Bradley was born at Netheravon, Wiltshire, on 28 November 1924. After success on the grass, he signed for Bristol and rode for the Bulldogs from 1948 to 1955. A world finalist and England international, he was captured by Southampton after Bristol's closure and made his debut on 21 June 1955, scoring twelve points against Poole. Bradley was a prolific scorer and was appointed captain in 1957. One of the country's top riders, he was a loyal team-man, appearing for the Saints in nine seasons of racing, and he is the second highest scorer in the club's history. (A.C. *Weedon*)

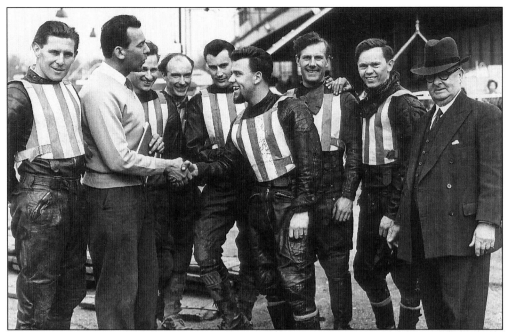

Southampton team manager Bert Croucher welcomes newly-signed England captain Brian Crutcher to Banister Court in 1957. From left to right: Johnny Hole, Alby Golden, Bill Holden, Brian Hanham, Maury Mattingly, Ron Sharp, Charlie Knott (promoter). *(Southern Newspapers Limited)*

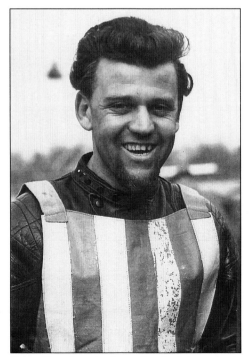

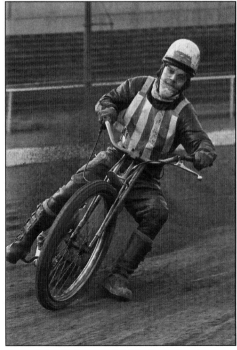

Brian Crutcher, in the red and white striped race jacket of the Saints and (right) putting in some pre-season practice on the Banister Court circuit. *(Southern Newspapers Limited)*

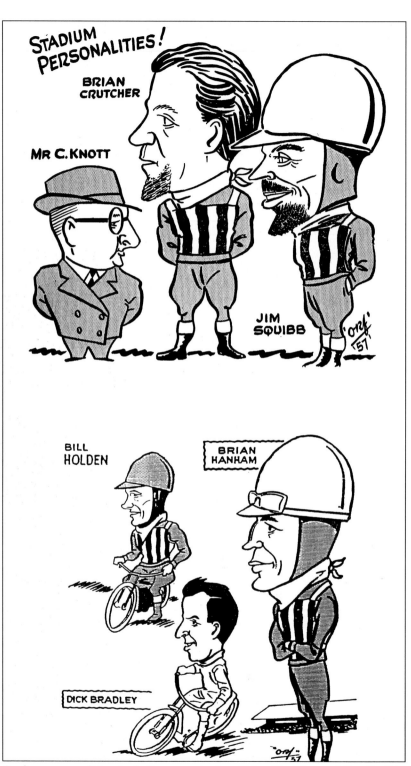

Stadium personalities, including new signings Brian Crutcher and Jim Squibb, brilliantly portrayed by 'Orf' in 1957. (*Southampton programmes, 1957*)

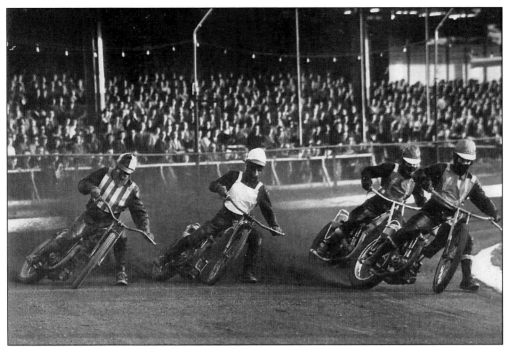

Exciting first-bend action in the *Sunday Pictorial* Challenge Trophy at Banister Court on 21 May 1957. From left to right: Brian Hanham (Southampton), Peo Soderman (Coventry), Jack Geran (Leicester), Ken McKinlay (Leicester).

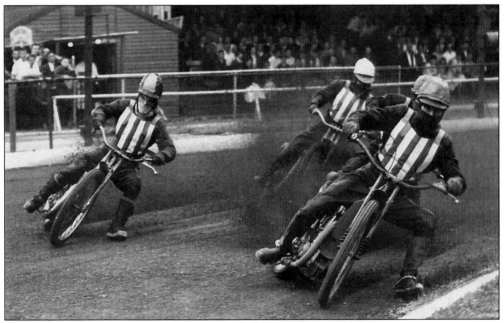

Contesting the first bend in heat one of the *Southern Daily Echo* Handicap meeting on 18 June 1957 are, from left to right: Saints riders Brian Crutcher, Bill Holden and Dick Bradley, with Swindon's George White behind Bradley. White went on to win the race and the cup. This was Crutcher's first defeat of the season on his home track. (*Southern Newspapers Limited*)

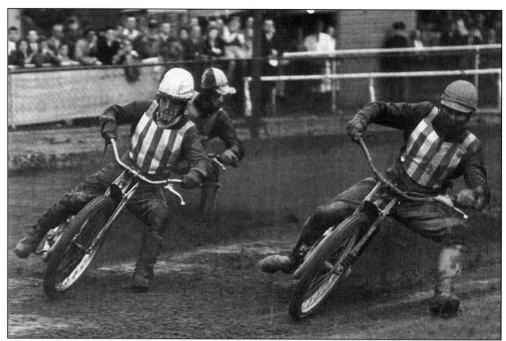

Southampton's Brian Crutcher and team-mate Dick Bradley sweep into the lead ahead of Swindon's Mike Broadbanks in heat five of the World Championship qualifying round at Banister Court on 16 July 1957. Crutcher won the meeting with a fifteen points maximum. (*Southern Newspapers Limited*)

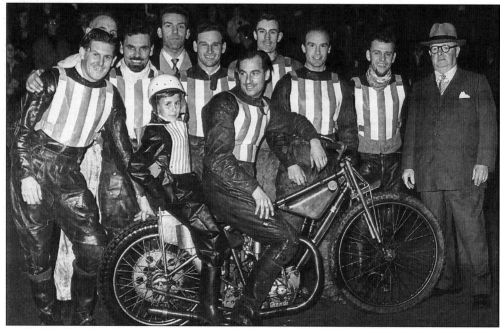

Southampton team, 1957. From left to right: Johnny Hole, Frank Hedgecott (mechanic), Jim Squibb, Bert Croucher (team manager), Alby Golden, Dick Bradley (captain, on machine) with Raymond Simmonds (team mascot), Brian Hanham, Bill Holden, Brian Crutcher, Charlie Knott (promoter).

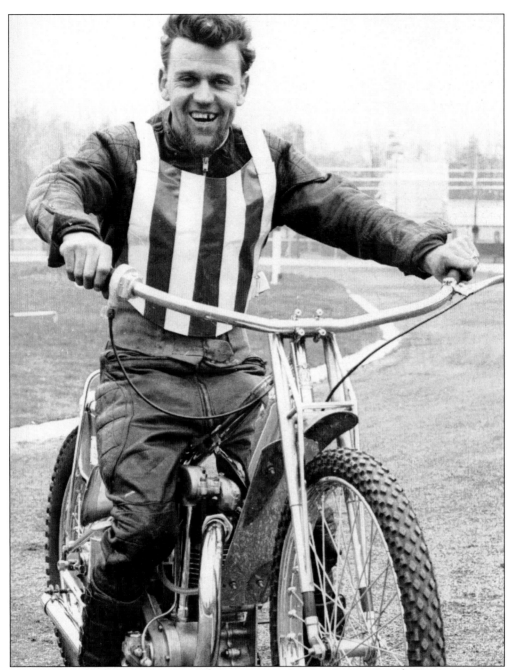

Saints star number thirteen – Brian Crutcher. Crutcher was born in Parkstone on 23 August 1934 and made his speedway debut for Poole in March 1951, scoring nine points from three rides against Exeter. The following week he broke the track record. After brilliant performances for the Pirates, he was snapped up by Wembley in 1953 for £2,500. Crutcher became the team's leading scorer, London Riders Champion, Match Race Champion, World Finalist and England Test captain. After Wembley's closure on 14 March 1957, he was signed by Southampton and was practically unbeatable at Banister Court, where he stayed until retiring in May 1960 at the grand old age of twenty-five. (A.C. Weedon)

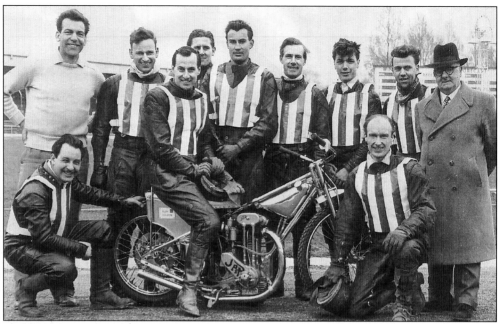

Southampton team, 1958. From left to right, back row: Bert Croucher (team manager), Alby Golden, Johnny Hole, Brian Hanham, Maury Mattingly, Brian Brett, Brian Crutcher, Charlie Knott (promoter). Front row: 'Split' Waterman, Dick Bradley (captain on machine), Bill Holden. (A.C.Weedon)

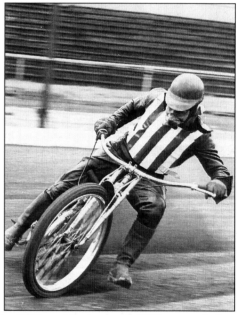

Left: Local man Bill Holden rejoined the Saints in 1956, and had a good 1957 season before returning to Poole the following year. *Right:* Former England international 'Split' Waterman joined Southampton in 1958 at the age of thirty-seven. A rider of vast experience, he has ridden for all the major London clubs and appeared in many World Finals. He scored well until deciding to retire for the season at the end of May. (A.C. Weedon)

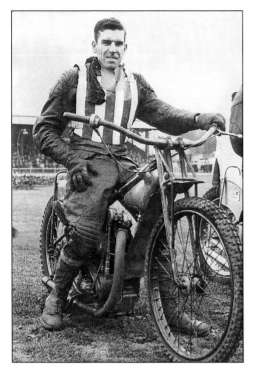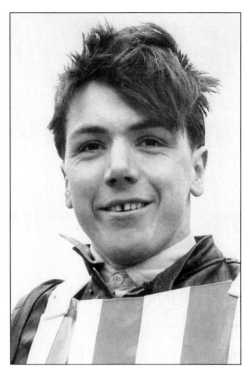

Left: Chum Taylor signed for the Saints in 1958 after several years' absence from British speedway. He stayed at Banister Court for four seasons, appearing in the World Final in 1960. *Right:* Brian Brett was given his first speedway opportunity at Banister Court in 1958, but moved on to Swindon halfway through the 1960 season. He was the top British scorer in the 1965 World Final when he rode in Newcastle's colours. *(A.C. Weedon)*

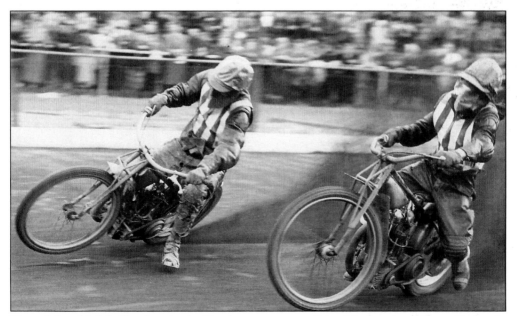

Two of the chief thrillmakers in the Southampton team, Brian Hanham and Chum Taylor, in exciting action at Banister Court in 1958. *(A.C. Weedon)*

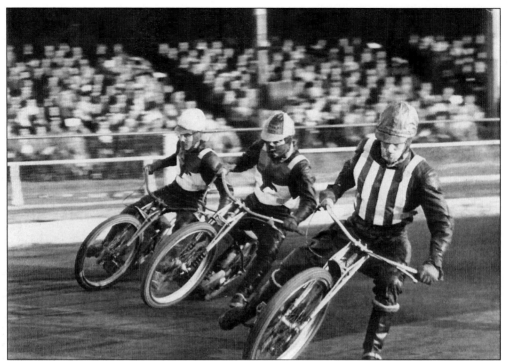

Southampton's Alby Golden leads Swindon's Ian Williams, on the outside, and Ernie Lessiter in heat one of the Britannia Shield match at Banister Court on 29 April 1958, which the Saints won 57-39. In this heat, Golden's partner, Jim Squibb, took second place to give the Saints a 5-1 victory. (A.C. *Weedon*)

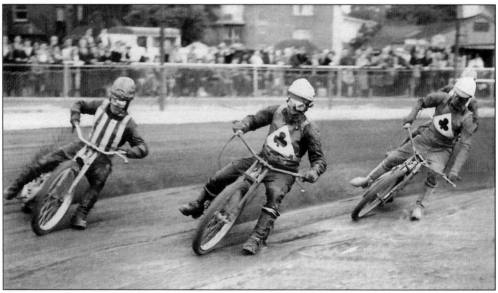

Southampton's Brian Crutcher roars around the outside of Belle Vue's Jack Kitchen and Ron Johnston, with partner Jim Squibb at the back, in heat one of the Saints-Aces clash at Banister Court on 17 June 1958. Squibb came through with one of his famous late dashes to take second place and clinch a 5-1 in the 67-29 victory. (A.C. *Weedon*)

Southampton Speedway had the honour of hosting three major internationals at Banister Court in the 1958 season, which was an indication of the status of the club at that time. It was the first occasion that Poland had appeared in an international in England, and Dick Bradley top-scored with fifteen points. Crutcher scored fifteen, Bradley twelve and Squibb one point from reserve against Sweden, while Crutcher got fifteen and Bradley ten against Australasia. All three tests were won by England. (*Southampton programmes, 1958*)

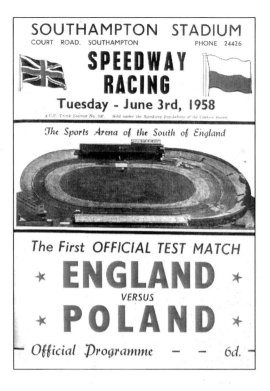

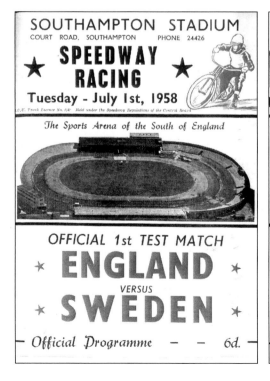

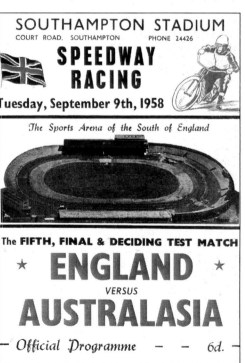

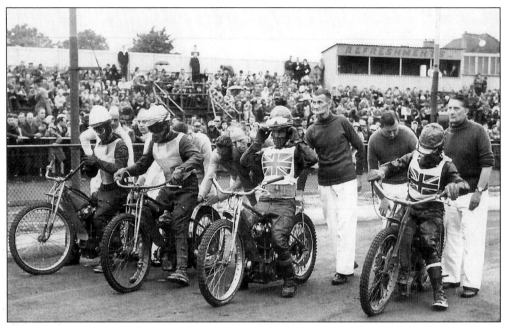

The riders get ready for the start of heat one of the England-Sweden Test at Banister Court on 1 July 1958. From left to right: Ove Fundin (Sweden), Birger Forsberg (Sweden), Brian Crutcher (England), Arthur Forrest (England). Southampton's Crutcher won from Fundin, Forsberg and Forrest in a time of 65 seconds. (*A.C. Weedon*)

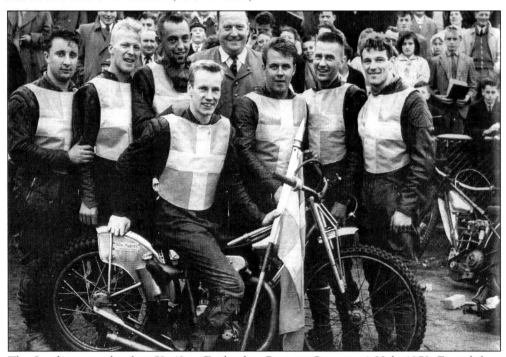

The Sweden team that lost 59–49 to England at Banister Court on 1 Huly 1958. From left to right: Dan Forsberg, Per Olaf Soderman, Birger Forsberg, Ove Fundin (captain on machine), Arne Bergstrom (team manager), Olle Nygren, Joel Jansson, Rune Sormander.

Southampton's Brian Crutcher being congratulated by Don Clarke of the *Sunday Pictorial* after winning the British Match Race Championship and the Golden Helmet. Crutcher previously held the championship in 1956, when he had been with Wembley, and he was the first post-war Southampton holder of the title after he defeated Ove Fundin in a run-off at Wimbledon on 4 August 1958. (*A.C. Weedon*)

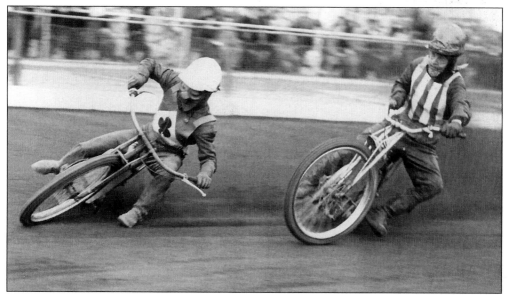

Two of England's greatest ever riders, Peter Craven (Belle Vue) and Brian Crutcher (Southampton), are seen here in a battle for league points at Banister Court on 17 June 1958. Craven won this particular duel in heat six of the Saints' big 67-29 victory. (*A.C. Weedon*)

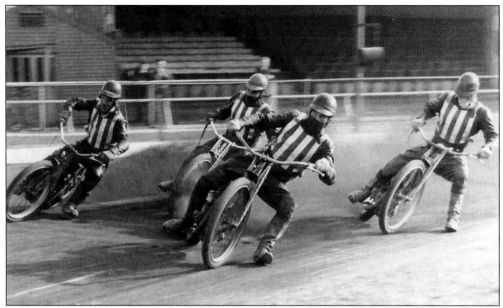

Saints riders take to the Banister Court track for some pre-season practice in March 1959. From left to right: Brian Crutcher, Jim Squibb, Dick Bradley, Alby Golden. *(Cecil Bailey)*

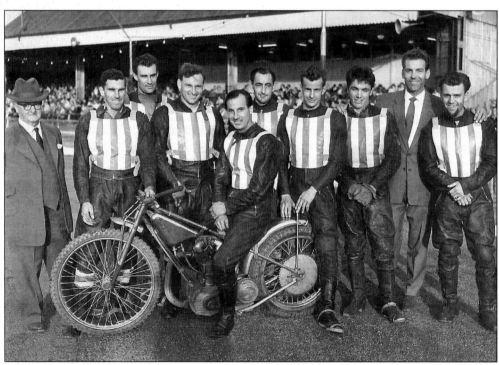

Southampton, 1959. From left to right: Charlie Knott (promoter), Chum Taylor, Brian Hanham, Alby Golden, Dick Bradley (captain, on machine), Geoff Mardon, Bjorn Knutsson, Brian Brett, Bert Croucher (team manager), Brian Crutcher. *(Cecil Bailey)*

Saints star number fourteen – Bjorn Knutsson. Knutsson was born in Norrkoping, Sweden on 27 April 1938, and scored nine points on his Saints' debut against Wimbledon on 21 July 1959. He was a big scorer for Southampton for four and a half seasons and won many individual honours. He was British Match Race Champion, Swedish Champion and appeared in many World Finals, finally taking the crown in 1965. Knutsson was the third highest all-time scorer for the Saints, and when they closed he captained West Ham in 1964. He retired prematurely, but admitted that if Southampton had not closed in 1963 he would have continued to ride for much longer. (*Cecil Bailey*)

Born in Christchurch, New Zealand, in 1931, Geoff Mardon was a discovery of Trevor Redmond and they rode together for Aldershot in 1951. He was an instant success and became the first Third Division rider to reach the World Final, where he was a non-riding reserve. Wimbledon snapped him up for £1,000 and he scored hundreds of points for them. He represented New Zealand in test matches and was third in the 1953 World Final. Mardon received an SCB award for being the highest scorer on away tracks in 1954 before returning to New Zealand. Charlie Knott persuaded him to join Southampton in 1959 and he was second highest scorer that season, despite missing some matches with a fractured jaw. He recovered well enough to reach the World Final with team-mate Brian Crutcher and returned to New Zealand for good at the end of the season. *(Cecil Bailey)*

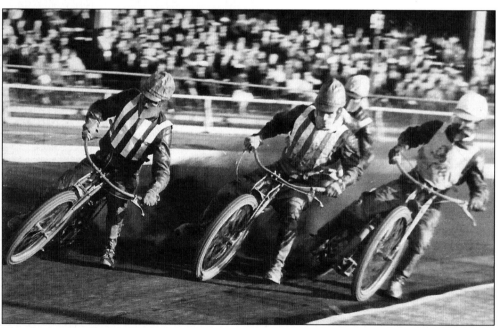

Heat four action from the controversial league match between the Saints and the Bees at Banister Court on 9 June 1959. The riders in front are, from left to right: Southampton's Brian Hanham and Alby Golden, and Coventry's former Saint, Maury Mattingly. Les Owen (Coventry) is at the back. Coventry won after appealing against Hanham riding at reserve, after returning from injury. *(Cecil Bailey)*

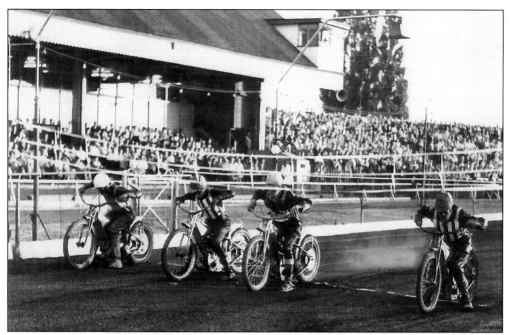

League action between the Saints and the Robins at Banister Court on 18 August 1959 with, from left to right: Trevor Redmond (Swindon), Bjorn Knutsson (Southampton), Ian Williams (Swindon) and Brian Hanham (Southampton) just leaving the starting gate. (*Cecil Bailey*)

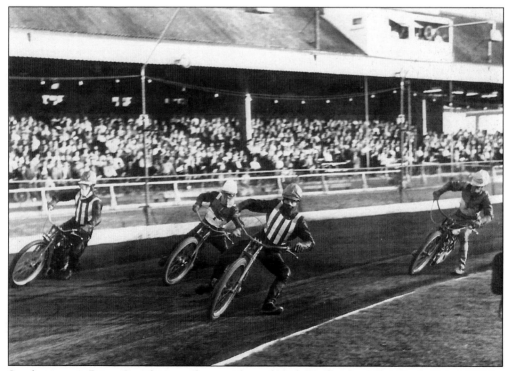

Southampton's Brian Crutcher, on the outside, and Dick Bradley lead Swindon's George White and Neil Street in the Saints' 54-36 league win on 18 August 1959. (*Cecil Bailey*)

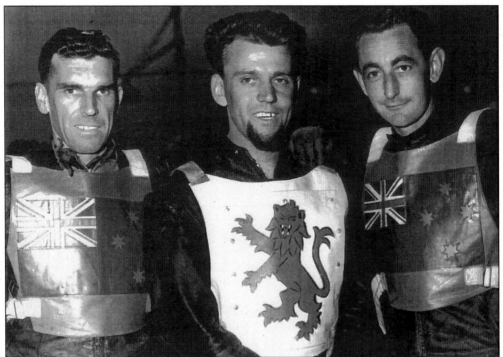

Southampton riders Chum Taylor, Brian Crutcher and Geoff Mardon rode in the first England-Australasia Test Match held at Banister Court on 8 September 1959. Crutcher captained England but only scored a disappointing two points, while Mardon and Taylor scored eight and five respectively for Australasia.

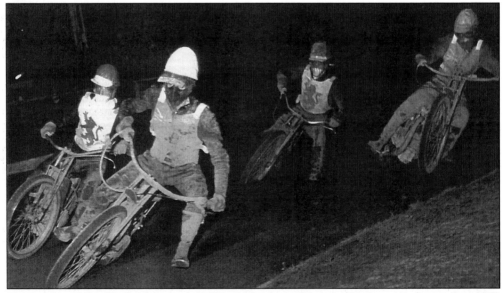

Heat eight of the England-Australasia Test Match at Banister Court on 8 September 1959 sees Australasia's Peter Moore in the lead, with England's Ron How on the outside, and Brian Crutcher holding off Saints' team-mate Geoff Mardon. Moore won in 62 seconds from How, Mardon and Crutcher. Australasia won the meeting 56-52.

The directors of Southern Speedway Promotions Limited were Charlie Knott, the 'Guv'nor', and his sons Charlie Jnr (on the left) and Jack. After years working hard behind the scenes, Jack took over the announcing duties from Jim Reader in the mid 1950s, and also announced at two Wembley World Finals and the Internationale. Charlie Jnr was particularly prominent in 1958, and he ran the show at Banister Court when his father was ill. Jack Knott was part of the brief Provincial League revival at Bristol, and then successfully took over the administration of Poole Speedway with Charles Foot in 1960, while Charlie Jnr performed the duties of Poole's Clerk of the Course.

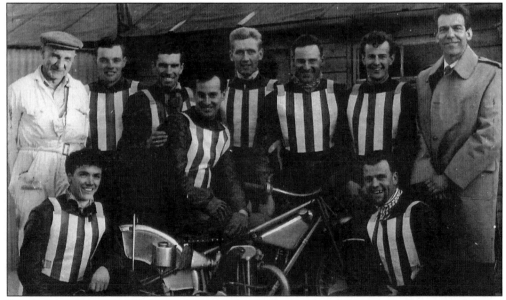

Southampton team, 1960. From left to right, back row: Frank Hedgecott (mechanic), Peter Vandenberg, Chum Taylor, Jack Scott, Alby Golden, Bjorn Knutsson, Bert Croucher (team manager). Front row: Brian Brett, Dick Bradley (captain, on machine), Brian Crutcher.

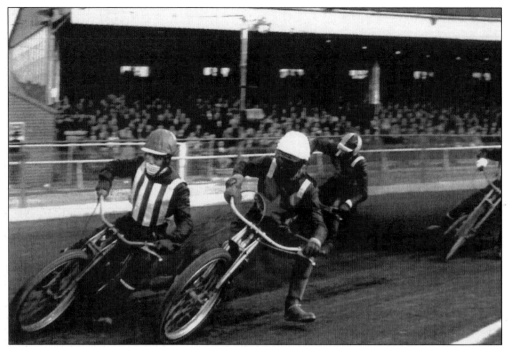

Heat one of the Britannia Shield match at Banister Court, between the Saints and the Dons on 3 May 1960. Wimbledon's Ronnie Moore dived inside home star Brian Crutcher and went on to win, setting up a new track record of 60.6 seconds. Southampton's Jack Scott kept out Cyril Brine to secure third place. *(Cecil Bailey)*

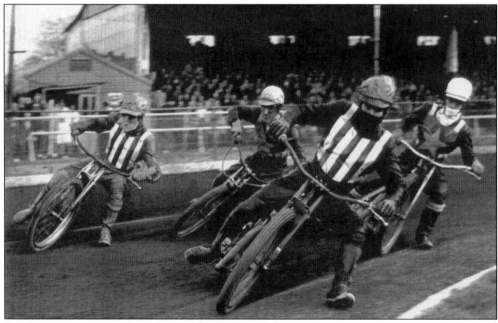

Southampton captain Dick Bradley leads, from left to right, team-mate Chum Taylor and Wimbledon pair Gerald Jackson and Ron How in heat three of the meeting on 3 May 1960. How came through to win from Taylor and Bradley and the Dons won the match 48-42. *(Cecil Bailey)*

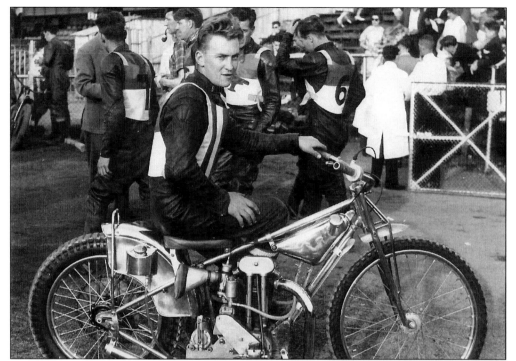

Swedish rider Alf Jonsson in the pits at Banister Court. One of the top riders in his country, he was brought to Southampton to replace the retired Brian Crutcher. Unfortunately, in his third meeting, on 21 June 1960, he broke his leg and was unable to ride for the Saints again. *(Cecil Bailey)*

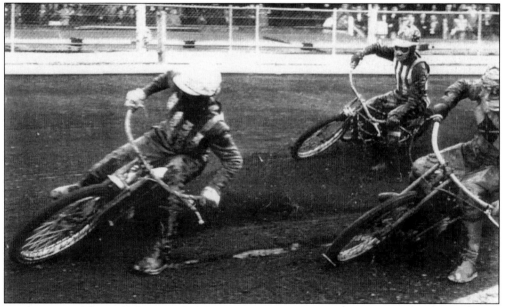

At the start of the sixth heat of the New Cross-Southampton league match at the Old Kent Road on 15 June 1960, new Saints signing Alf Jonsson is just ahead of Leo McAuliffe (New Cross) with the Saints' Peter Vandenberg on the outside. New Cross took the league points with a 50-37 victory.

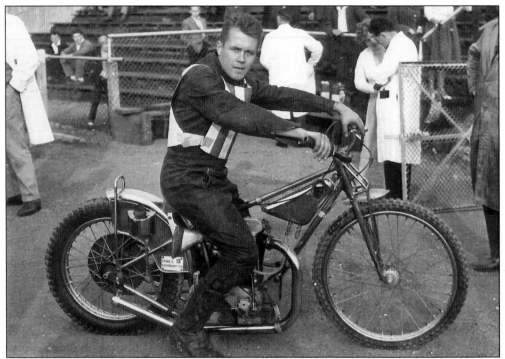

One of the world's greatest riders, Swedish star Olle Nygren, made his debut for Southampton against Leicester on 28 June 1960. Many times a world finalist, he finished third in 1954 after losing a run-off for second place to Brian Crutcher, who was then with Wembley. Nygren had a very successful period with the Saints, achieving double-figure scores ten times in thirteen matches. *(Cecil Bailey)*

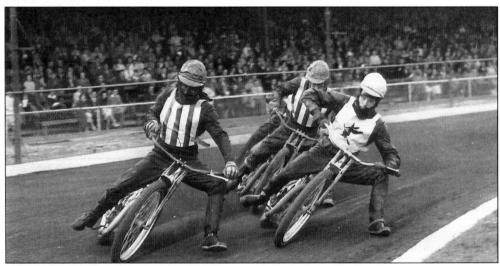

Racing into the first bend in heat two of the Saints-Witches league match at Banister Court on 12 July 1960 are Olle Nygren (Southampton) and Les McGillivray (Ipswich) with Alby Golden (Southampton) and Jim Squibb (Ipswich) at the back. Nygren won from McGillivray in 64 seconds, but ex-Saint Squibb snatched third place from former team-mate Golden and Ipswich won the match 46-44. *(Cecil Bailey)*

Six

1961-1963

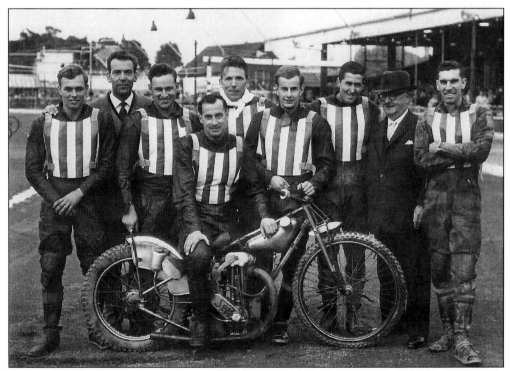

Southampton team, 1961. From left to right: Peter Vandenberg, Bert Croucher (team manager), Alby Golden, Dick Bradley (captain, on machine), Cyril Roger, Bjorn Knutsson, Barry Briggs, Charlie Knott (promoter), Chum Taylor. *(Cecil Bailey)*

Southampton's promoter Charlie Knott welcomes his new rider, New Zealander Barry Briggs, to Banister Court at the beginning of the 1961 season. He was signed in the face of stiff competition from London clubs Wimbledon, his parent track, and New Cross, for whom he rode on loan in 1960. The 'Guv'nor' had tried to sign Briggs two years before, when he had wanted a transfer from Plough Lane. 'If at first you don't succeed … '

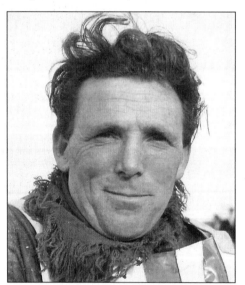 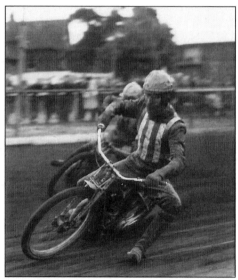

Cyril Roger was born in Ashford, Kent, and started his speedway career as a novice at New Cross in 1946. He was loaned to Exeter and became a big star in the South West. Recalled to the Old Kent Road in 1948, he became one of the Rangers' greatest ever riders, also riding for Norwich, Poole and Ipswich. An England international and World Finalist, he was signed in 1961 by Southampton, where, despite his veteran status, he gave excellent service for three years. (A.C. *Weedon and Cecil Bailey*)

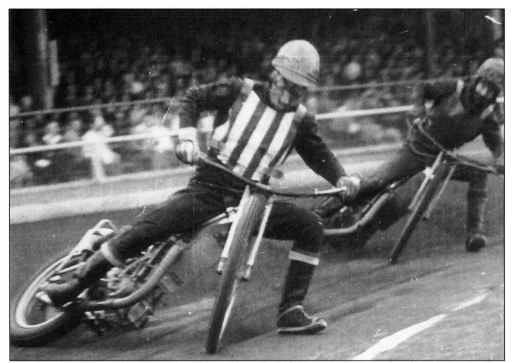

Southampton's Bjorn Knutsson leading Ove Fundin at Banister Court in the first leg of the Match Race Championship on 22 August 1961, which he won 2-0.

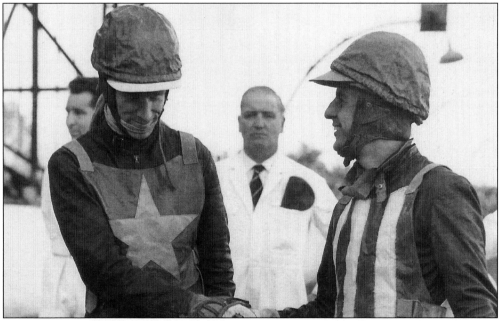

Norwich's Ove Fundin and Southampton's Bjorn Knutsson wish each other well before the second leg of the Match Race Championship at Norwich on 1 September 1961. Knutsson won 2-0 to take the Golden Helmet from fellow Swede Fundin. It was the first time that two foreign riders had competed for the championship.

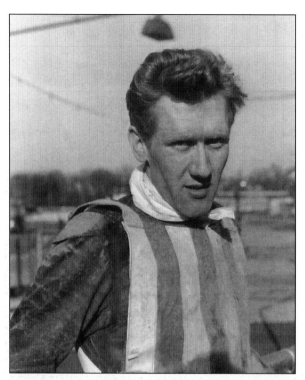

Australian Jack Scott joined Southampton in 1959, and arrived at Banister Court with a big reputation after much success in his home country. However, despite occasionally showing his potential, he had a disappointing couple of seasons. In the winter of 1960/61, he had the good fortune to have a big pools win and he invested in top-class equipment. Charlie Knott loaned Scott to Plymouth in the Provincial League in 1961, where he was virtually unbeatable. A very stylish rider, when he rode for the Saints he scored plenty of points and Charlie Knott tried to get his loan cancelled. The SCB would not allow it and this almost certainly cost the Saints the league championship. Individually, Scott also did well in 1961, reaching the British Final of the World Championship. (Cecil Bailey)

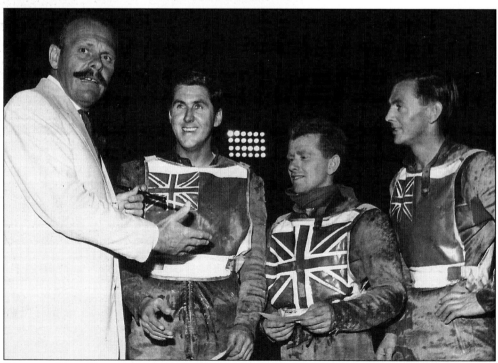

Film actor Terry-Thomas presents the winner's cheque to Southampton's Barry Briggs at the British Final of the World Championship at Wembley on 2 September 1961. Looking on are second-placed Peter Craven (Belle Vue) and Ronnie Moore (Wimbledon), who was third. (A.C. Weedon)

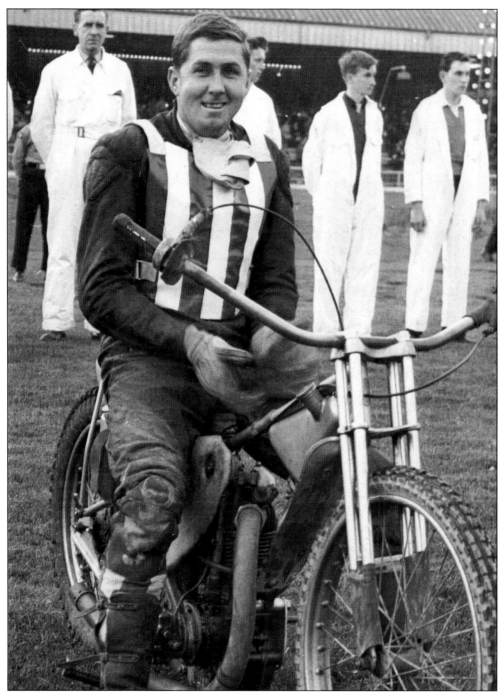

Saints star number fifteen – Barry Briggs. Briggs was born in Christchurch, New Zealand on 30 December 1934 and came to England to join Wimbledon in 1952. Somewhat wild initially, he became one of speedway's greatest-ever riders. He won many individual honours, including four World Finals, and the first six British League Riders Championship Finals. Charlie Knott signed him for only £750 in 1961 and, together with Bjorn Knutsson, he raised the level of speedway at Banister Court, helping his promoter win the coveted National League title in 1962.

Southampton's championship-winning team, 1962. From left to right: Charlie Knott (promoter), Alby Golden, Dick Bradley (captain), Peter Vandenberg, Tony Knott (team mascot), Cyril Roger, Reg Luckhurst, Barry Briggs, Bjorn Knutsson, Bert Croucher (team manager). *(Cecil Bailey)*

Southampton's Barry Briggs leading Ove Fundin at Banister Court in the second leg of the Match Race Championship on 26 June 1962, which he won 2-0. However, Fundin won the first leg at Norwich 2-0, when the Saints' rider's engine packed up twice, and the decider at Oxford 2-1. He therefore retained the Golden Helmet, which he first won in 1958. *(Cecil Bailey)*

114

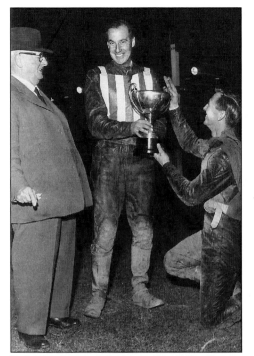
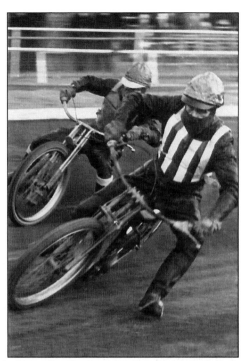

Left: Southampton's skipper Dick Bradley proudly holding the 'Pride of the South' trophy which he won on 1 May 1962, and being congratulated by Charlie Knott and Wimbledon's Ronnie Moore. *Right:* Saints star Bradley in action.

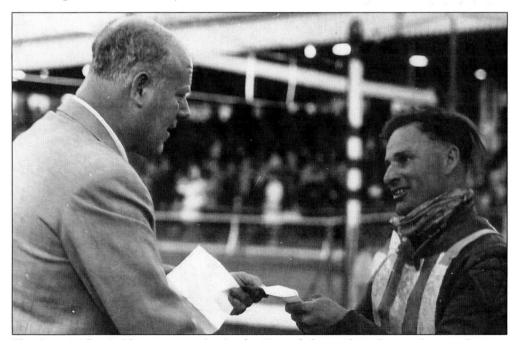

The Saints' Alby Golden receiving the *Sunday Pictorial* cheque from George Casey at Banister Court, after winning the Southampton round of the World Championship on 3 July 1962. Golden tied with Swindon's Neil Street on twelve points and subsequently won the run-off.

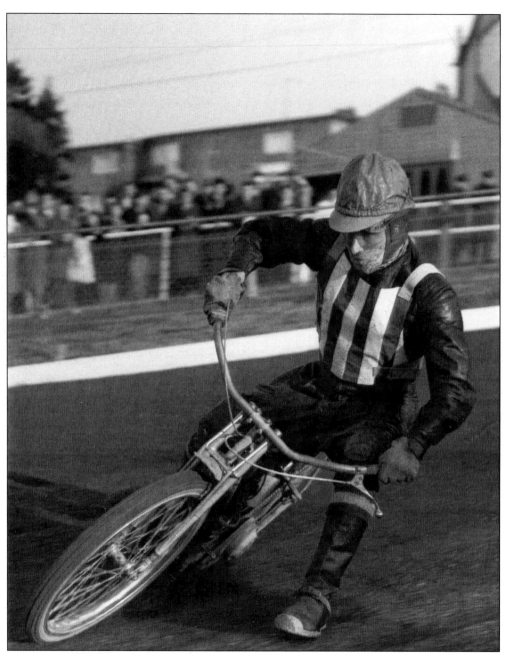

Saints star number sixteen – Alby Golden. Golden was born just outside Totton on 14 March 1931, and first put on the famous red and white colours in 1955 after skippering the Ringwood Turfs and winning the Southern Area League Riders Championship. He rode at the stadium until it closed and is the fifth highest scoring Southampton rider in the team's history. His forceful, aggressive style endeared him to the Banister Court faithful and he provided the thrills the crowds loved to see. Golden's appearance record is extraordinary – he was an ever-present in five of the nine seasons in which he rode and only missed one match in each of a further three seasons. After the Saints closed, he had a very successful five and a half years captaining Newport and retired after breaking a leg riding for Eastbourne in 1970. *(Cecil Bailey)*

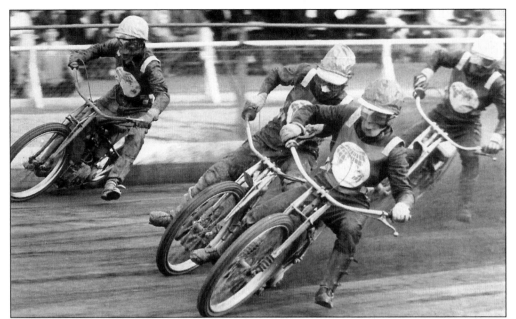

Belle Vue's Peter Craven leads Southampton's Barry Briggs in heat one of the World Championship semi-final at Banister Court on 24 July 1962, with Wimbledon's Bob Andrews on the outside and Ronnie Moore at the back. Craven won the meeting with a fifteen points maximum and Briggs was runner-up with fourteen. (*Cecil Bailey*)

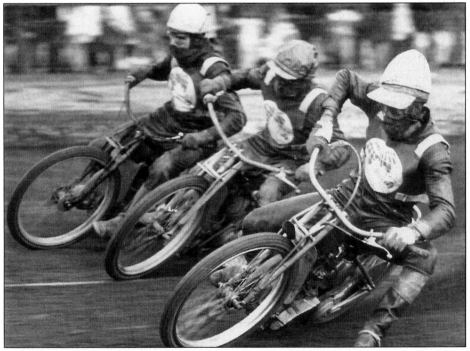

Heat three of the World Championship semi-final on 24 July 1962. Southampton's Cyril Roger is on the outside of Dick Fisher (Belle Vue) and Mike Broadbanks (Swindon), but finished behind Broadbanks, Fisher and Norwich's Billy Bales. (*Cecil Bailey*)

Old Etonian Mike Erskine, on the left, contributed much to Southampton Speedway. He passed on his riding expertise and mechanical knowledge as team manager from 1952 to 1955, when Bert Croucher (middle) took over the role. Both men gave very loyal support to the 'Guv'nor', and Jon Erskine, pictured on the right, is listening and learning. *(Cecil Bailey)*

Southampton's Cyril Roger making a strong point in the Banister Court pits. Watching him are, from left to right: Saints' skipper Dick Bradley, former team manager Mike Erskine, who looks thoroughly bemused by the whole thing, and Freddie Pike, who was associated with the Ringwood Turfs at Matchams Park. *(Cecil Bailey)*

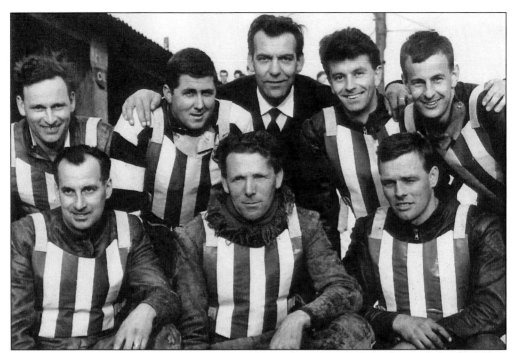

Southampton team, 1963. From left to right, back row: Alby Golden, Barry Briggs, Bert Croucher (team manager), Reg Luckhurst, Bjorn Knutsson. Front row: Dick Bradley (captain), Cyril Roger, Peter Vandenberg. (*Speedway Star*)

Stan Stevens joined Southampton from the defunct New Cross track and on 20 August 1963, riding from scratch, won the Derek Shackleton Trophy in the second half. He beat Norwich's Ove Fundin, Reg Luckhurst (Southampton) and Chum Taylor (Oxford). The Hampshire and England cricketer Derek Shackleton is seen here presenting the trophy, watched by promoter Charlie Knott and son Charlie Jnr, who was a team-mate of Shackleton in the Hampshire cricket side. (*Speedway Star*)

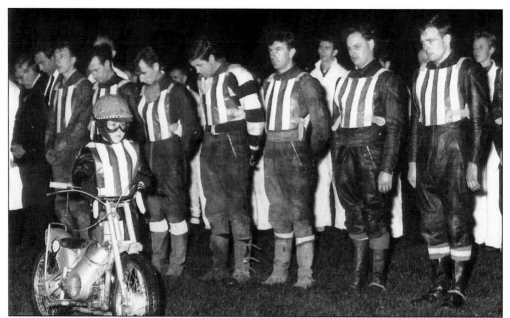

The Saints line up for their last ever meeting at Banister Court, on a rain-swept October night, and pay their respects to Peter Craven, who had been killed the previous month. From left to right: Dr Carl Biagi, Bert Croucher (team manager), Stuart Wallace, Ross Gilbertson, Stan Stevens, Barry Briggs, Reg Luckhurst, Alby Golden, Peter Vandenberg. At the front is team mascot Tony Knott. (*Southern Newspapers Limited*)

The scene at the pits gate on the fourth bend at the very last speedway meeting at Banister Court Stadium, on Thursday 3 October 1963. The challenge match between Southampton and Wimbledon, postponed from the previous Tuesday, went ahead despite torrential rain and a track which was literally under water. It was obvious that the rider who gated first on the rain-soaked track was likely to win. The Saints responded well to the conditions and beat the Dons 43-35. (*Speedway Star*)

Seven

The Championship Years

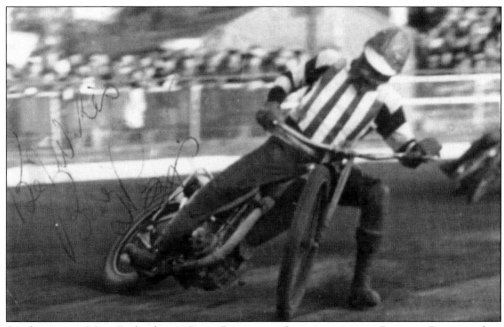

Southampton's New Zealand star, Barry Briggs, seen here in action at Banister Court, made a huge contribution to their winning of the 1962 National League Championship.

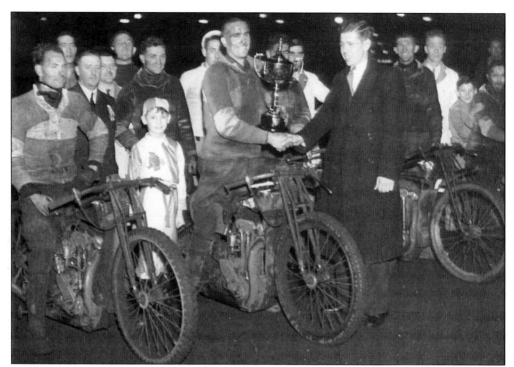

Harringay and England captain, Jack Parker, presenting the Provincial League Championship trophy to Southampton's captain Frank Goulden at Banister Court, on 24 September 1936, after the 41½-29½ victory over close rivals Bristol Bulldogs. From left to right: Cyril Anderson, Charlie Knott (promoter), Sid Griffiths, Frank Goulden, Fred Strecker, Jack Parker, Bert Jones, Art Fenn. A near-record crowd of 18,000 flooded into the stadium – including three trainloads from Bristol – to watch the match which decided the championship. The Saints were brilliantly led by Goulden, who rode unbeaten throughout the meeting. (*Southern Newspapers Limited*)

1936 National League Division Two (Provincial League)

	P	W	D	L	FOR	AGST	PTS
Southampton	16	10	0	6	618½	518½	20
Bristol	16	10	0	6	593½	536½	20
Nottingham	16	9	0	7	601½	548½	18
Liverpool	16	9	0	7	555	577	18
Plymouth	16	2	0	14	476½	662½	4

1936

Date	Opponent			Result	FRANK GOULDEN	BILLY DALLISON	SID GRIFFITHS	BERT JONES	HARRY LEWIS	ALEC STATHAM	BOB LOVELL	CYRIL ANDERSON	FRED STRECKER	VIC COLLINS	ART FENN	BOB EVEMY	DICKY SMYTHE	STEWART MANNING	S.WEBB
APR 10	CARDIFF	(NT)	H W	38-33	9	-	6	9	7	4	3	-	-	-	-	-	-	0	-
13	CARDIFF	(NT)	A W	38-33	9	-	4	10	8	5	2	-	-	-	-	-	-	-	-
16	LIVERPOOL	(LGE)	H L	35-37	5	-	6	6	7	9	-	2	-	-	-	-	-	-	-
23	NOTTINGHAM	(LGE)	H W	53½-17½	7	-	6½	10	11	7	-	-	12	-	-	-	-	-	-
29	** CARDIFF	(LGE)	A W	37-33	7	-	7	6	6	5	-	-	6	-	-	-	-	-	-
MAY 7	PLYMOUTH	(LGE)	H W	49-20	9	-	9	12	5	1	4	-	9	-	-	-	-	-	-
8	BRISTOL	(LGE)	A L	32-38	7	-	6	3	2	11	1	-	-	-	2	-	-	-	-
13	4 TEAM T'MENT	(CHALL)	*	3RD	-	-	9	-	-	-	-	5	-	-	5	1	-	-	-
14	LIVERPOOL	(NT)	H W	42-28	10	9	-	7	3	7	-	-	6	-	-	-	-	-	-
18	LIVERPOOL	(NT)	A L	31-39	2	12	3	4	3	1	-	-	6	-	-	-	-	-	-
21	** CARDIFF	(LGE)	H W	50-22	9	12	5	7	6	1	-	-	10	-	-	-	-	-	-
26	NOTTINGHAM	(LGE)	A W	41-30	7	-	11	5	5	-	-	4	9	-	-	-	-	-	-
28	BRISTOL	(LGE)	H W	43-29	2	11	8	7	2	5	-	-	8	-	-	-	-	-	-
JUN 1	LIVERPOOL	(LGE)	A L	31-40	3	-	10	4	4	5	-	3	-	-	-	-	-	-	2
4	HARRINGAY	(NT)	H L	30-41	5	3	7	1	1	4	-	2	7	-	-	-	-	-	-
11	LIVERPOOL	(PROV T)	H W	43-27	8	11	9	-	4	2	1	-	8	-	-	-	-	-	-
12	BRISTOL	(PROV T)	A W	38-32	7	8	7	-	6	2	-	-	8	-	-	-	-	-	-
16	PLYMOUTH	(LGE)	A L	25-47	7	-	2	6	3	3	-	-	-	4	-	-	-	-	-
18	WEST HAM HAWKS	(PROV T)	H W	52-20	7	11	7	10	3	6	-	-	8	-	-	-	-	-	-
25	PLYMOUTH	(PROV T)	H W	44-27	7	12	4	9	-	-	-	-	7	1	4	-	-	-	-
30	NOTTINGHAM	(PROV T)	A W	39-31	5	6	5	8	-	-	-	-	9	-	6	-	-	-	-
JUL 9	NOTTINGHAM	(PROV T)	H W	42-28	8	5	9	8	-	-	4	-	6	-	2	-	-	-	-
30	AMERICA	(CHALL)	H W	38-34	3	11	8	6	-	-	5	1	-	-	4	-	-	-	-
AUG 6	PLYMOUTH	(LGE)	H W	49-23	9	6	9	5	-	8	-	-	9	-	3	-	-	-	-
11	PLYMOUTH	(PROV T)	A L	30-42	6	5	9	7	-	-	-	-	1	-	2	-	-	-	-
20	WEST HAM HAWKS	(PROV T)	H W	44-28	11	6	8	9	-	2	-	1	7	-	-	-	-	-	-
27	NOTTINGHAM	(LGE)	H W	42-30	9	7	7	10	-	1	-	-	8	-	-	-	-	-	-
31	LIVERPOOL	(PROV T)	A L	33-39	6	8	6	7	-	1	-	-	6	-	5	-	-	-	-
SEP 1	AMERICA	(CHALL)	H W	56-50	10	9	11	5	-	2	-	-	-	-	10	-	9	-	-
4	BRISTOL	(LGE)	A W	37-35	8	8	9	2	-	-	-	-	8	-	-	-	2	-	-
7	LIVERPOOL	(LGE)	A L	30-40	4	0	9	4	-	3	-	-	8	-	2	-	-	-	-
10	LIVERPOOL	(LGE)	H W	43-27	9	-	10	11	-	-	-	-	8	-	3	-	2	-	-
15	PLYMOUTH	(LGE)	A W	43-29	11	-	9	11	-	-	5	-	4	-	3	-	-	-	-
17	BRISTOL	(PROV T)	H L	29-40	10	-	4	0	-	4	-	3	6	-	2	-	-	-	-
22	NOTTINGHAM	(LGE)	A L	24-47	0	-	4	9	-	2	-	0	7	-	2	-	-	-	-
24	BRISTOL	(LGE)	H W	41½-29½	12	-	6	7	-	0	7½	-	4	-	5	-	-	-	-
29	AMERICA	(CHALL)	H W	43-29	9	-	4	12	-	-	-	4	8	-	6	-	-	-	-
OCT 10	BRISTOL	(CHALL)	* D	27-27	7	6	2	3	-	5	-	-	4	-	-	-	-	-	-
16	BRISTOL	(CHALL)	A L	20-34	-	-	6	5	-	7	-	2	-	-	-	-	-	-	-

* Tournament held at Cardiff.
 Cardiff 34, Nottingham 22, Southampton 20, Plymouth 19.
* At Harringay.
 Frank Goulden beat Eric Collins in a run off.
**Cardiff withdrew from the league so their
 results are deleted from the records.

The high spot of an illustrious career in speedway, as Southampton promoter Charlie Knott receives the 1962 National League Championship trophy from the Speedway Control Board chairman, George Allen, at the Palm Court Ballroom, Southampton. *(Southern Newspapers Limited)*

1962 National League Table

	P	W	D	L	FOR	AGST	PTS
Southampton	24	18	0	6	1084	785	36
Wimbledon	24	14	1	9	1034	836	29
Coventry	24	13	0	11	$992\frac{1}{2}$	$875\frac{1}{2}$	26
Belle Vue	24	12	1	11	886	984	25
Norwich	24	12	0	12	909	962	24
Swindon	24	9	2	13	869	997	20
Oxford	24	4	0	20	$767\frac{1}{2}$	$1102\frac{1}{2}$	8

1962

Date	Opponent	Type		Result	BARRY BRIGGS	DICK BRADLEY	BJORN KNUTSSON	PETER VANDENBERG	ALBY GOLDEN	CYRIL ROGER	REG LUCKHURST	BRIAN CLEMENTS	BRIAN HANHAM	CHARLIE MONK	BILL POWELL	ROSS GILBERTSON	TIM BUNGAY	PETE MUNDAY
APR 9	WIMBLEDON	(CHALL)	A	L 37–41	5	9	12	2	4	4	1	-	-	-	-	-	-	-
10	WIMBLEDON	(CHALL)	H	W 51–33	8	8	14	7	6	5	3	-	-	-	-	-	-	-
13	IPSWICH	(CHALL)	A	W 45–33	12	4	11	2	6	7	3	-	-	-	-	-	-	-
20	COVENTRY	(LGE)	H	W 50–28	9	7	12	6	3	10	3	-	-	-	-	-	-	-
23	WIMBLEDON	(LGE)	A	L 30–47	12	5	2	1	3	4	3	-	-	-	-	-	-	-
28	BELLE VUE	(K.O.CUP)	A	L 37–40	5	2	9	5	7	4	5	-	-	-	-	-	-	-
MAY 3	OXFORD	(LGE)	A	W 44–34	10	6	-	7	2	10	8	1	-	-	-	-	-	-
8	WIMBLEDON	(LGE)	H	W 46–32	11	0	7	7	9	7	5	-	-	-	-	-	-	-
12	SWINDON	(LGE)	A	W 41–36	11	1	12	7	4	1	5	-	-	-	-	-	-	-
15	NORWICH	(LGE)	H	W 53–25	12	6	11	8	5	8	3	-	-	-	-	-	-	-
29	SWINDON	(LGE)	H	W 48–30	6	8	8	5	12	2	7	-	-	-	-	-	-	-
JUN 1 **	IPSWICH	(LGE)	A	W 51–27	12	8	9	5	8	2	7	-	-	-	-	-	-	-
5	OXFORD	(LGE)	H	W 60–18	12	6	12	6	6	8	10	-	-	-	-	-	-	-
9	BELLE VUE	(LGE)	A	L 36–42	7	6	7	2	2	6	6	-	-	-	-	-	-	-
12	BELLE VUE	(LGE)	H	W 46–32	9	6	8	5	4	7	7	-	-	-	-	-	-	-
16	COVENTRY	(NT)	A	W 43–41	6	2	12	13	3	1	6	-	-	-	-	-	-	-
18	WIMBLEDON	(LGE)	A	W 42–36	9	5	12	7	3	2	4	-	-	-	-	-	-	-
19	COVENTRY	(NT)	H	W 56–28	14	4	14	7	7	2	7	-	-	-	-	-	-	-
26 **	IPSWICH	(LGE)	H	W 60–18	11	1	12	8	8	8	12	-	-	-	-	-	-	-
JUL 10	WIMBLEDON	(LGE)	H	W 53–25	7	6	11	8	6	11	4	-	-	-	-	-	-	-
12	OXFORD	(LGE)	A	W 54–24	9	10	10	12	6	4	3	-	-	-	-	-	-	-
17	NORWICH	(LGE)	H	W 58–20	12	4	12	10	6	8	6	-	-	-	-	-	-	-
21	SWINDON	(LGE)	A	W 47–31	12	3	12	11	4	3	2	-	-	-	-	-	-	-
28	COVENTRY	(LGE)	A	W 41–37	8	4	9	8	2	3	7	-	-	-	-	-	-	-
31	CONTINENTALS	(CHALL)	H	W 52–44	13	5	9	11	8	5	1	-	-	-	-	-	-	-
AUG 7	SWINDON	(CHALL)	H	W 44–34	12	3	12	6	4	2	5	-	-	-	-	-	-	-
13	WIMBLEDON	(NT S-F)	A	L 33–50	14	0	11	4	2	1	1	-	-	-	-	-	-	-
14	WIMBLEDON	(NT S-F)	H	D 42–42	10	1	8	4	11	6	-	-	2	-	-	-	-	-
18	BELLE VUE	(CHALL)	A	D 39–39	7	5	12	2	6	5	2	-	-	-	-	-	-	-
21	COVENTRY	(LGE)	H	W 52–36	8	3	12	7	9	8	5	-	-	-	-	-	-	-
25	COVENTRY	(LGE)	A	L 31–47	9	0	11	2	6	2	1	-	-	-	-	-	-	-
28	OXFORD	(LGE)	H	W 59–19	12	3	11	8	11	7	7	-	-	-	-	-	-	-
SEP 1	NORWICH	(LGE)	A	L 36–42	8	0	7	5	6	4	6	-	-	-	-	-	-	-
4	BELLE VUE	(LGE)	H	W 49–29	10	5	11	6	7	7	-	-	3	-	-	-	-	-
14	SWINDON	(CHALL)	A	L 37–41	10	2	8	3	7	0	-	-	-	7*	-	-	-	-
15	BELLE VUE	(LGE)	A	L 35–43	7	11	4	3	5	4	-	-	-	-	1‡	-	-	-
18	SWINDON	(LGE)	H	W 42–35	11	5	10	4	5	5	-	-	2	-	-	-	-	-
24	EXETER	(CHALL)	A	W 45–33	-	7	-	10	5	9	-	-	-	-	-	9‡	4‡	1‡
25	PICK OF NAT.LGE	(CHALL)	H	W 50–27	7	9	9	7	10	8	-	-	-	0*	-	-	-	-
29	NORWICH	(LGE)	A	L 31–47	9	2	8	2	8	1	-	-	-	-	-	-	-	1‡

* Rode as guest
‡ Rode on loan

** Ipswich withdrew from the league after 15 matches so
their league results are deleted from the records.

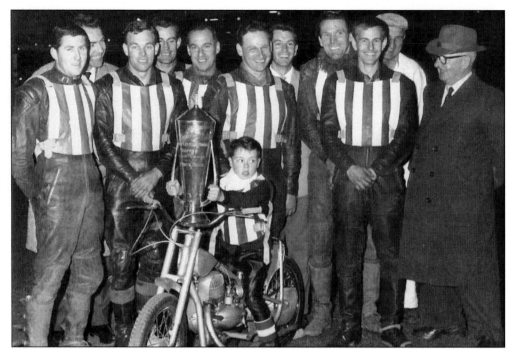

Southampton Speedway team – National League Champions, 1962. From left to right: Barry Briggs, Bert Croucher (team manager), Peter Vandenberg, Brian Hanham, Dick Bradley (captain), Alby Golden, Reg Luckhurst, Cyril Roger, Bjorn Knutsson, Frank Hedgecott (mechanic), Charlie Knott (promoter). Sitting in the front on his machine is the team mascot, Tony Knott, holding the trophy.

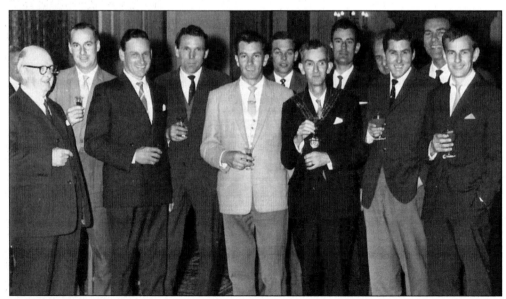

The Saints enjoyed a civic reception in the mayor's parlour to celebrate their success. From left to right: Charlie Knott Jnr (in background), Charlie Knott, Dick Bradley, Alby Golden, Cyril Roger, Reg Luckhurst, Peter Vandenberg, Councillor E.K. Lyons (mayor), Brian Hanham, Frank Hedgecott, Barry Briggs, Bert Croucher, Bjorn Knutsson. (*Southern Newspapers Limited*)

Eight

The Seventieth Anniversary Reunion

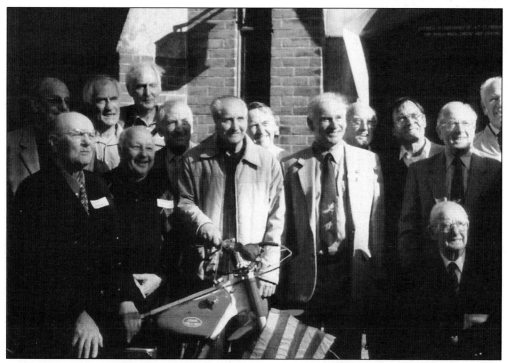

Some of the former Southampton riders and officials at the Seventieth Anniversary Reunion on Saturday 17 October 1998. From left to right: Bjorn Knutsson, Bob Oakley, Brian Hanham, Norman Strachan, Jack Vallis, Stan Stevens, Cecil Bailey, Keith Whipp, Alby Golden, Leo McAuliffe, Pete Munday, Charlie Knott Jnr (seated), Jim Knott, Tom Misselbrook. (*Gordon Elsworth*)

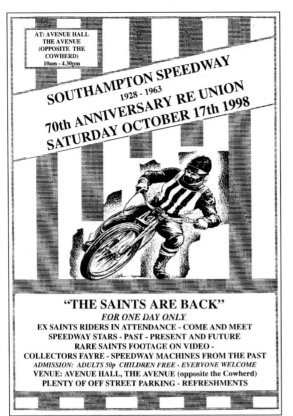

The successful reunion of Southampton Speedway took place at the Avenue Hall on Saturday 17 October 1998 and raised in the region of £350 for the Speedway Riders Benevolent Fund. A huge number of supporters turned up throughout the day, and main organiser Andy Scorey is to be congratulated for the effort put in to reunite so many Banister Court favourites. Bjorn Knutsson and his wife, Madeleine, flew in from Sweden especially to join in the celebrations. Other former riders present were Bob Oakley, George Bason, Cecil Bailey, Bill Holden, Maury Mattingly, Dennis Cross, Jack Vallis, Brian Hanham, Alby Golden, Brian Crutcher, Leo McAuliffe, Ross Gilbertson, Brian Brett, Pete Munday, Stan Stevens, Stuart Wallace, Norman Strachan and even a few riders from other clubs. The special guests were Charlie Knott Jnr, Jim Knott and well-known speedway journalist Cyril J. Hart. An impressive display of memorabilia was on show to captivate those who attended a really special day.

Just a few of the enthusiastic Southampton Speedway supporters, young and old, who were present at the Seventieth Anniversary Reunion. (*Gordon Elsworth*)